# THE SAGRADA FAMÍLIA

# THE SAGRADA FAMÍLIA

*The Astonishing Story of Gaudí's Unfinished Masterpiece*

Gijs van Hensbergen

BLOOMSBURY

NEW YORK · LONDON · OXFORD · NEW DELHI · SYDNEY

Bloomsbury USA
An imprint of Bloomsbury Publishing Plc

| 1385 Broadway | 50 Bedford Square |
|---|---|
| New York | London |
| NY 10018 | WC1B 3DP |
| USA | UK |

www.bloomsbury.com

First published in 2016 in Spain as *La Sagrada Família* by Rosa Dels Vents,
Penguin Random House Grupo Editorial, S. A. U., Barcelona

First published in Great Britain 2017
First U.S. edition 2017

ISBN: HB: 978-1-63286-781-0
EPUB: 978-1-63286-783-4

Library of Congress Cataloging-in-Publication Data is available.

2 4 6 8 10 9 7 5 3 1

Typeset by NewGen Knowledge Works (P) Ltd., Chennai, India
Printed and bound in the U.S.A. by Berryville Graphics Inc., Berryville, Virginia

To find out more about our authors and books visit www.bloomsbury.com. Here you will find extracts, author interviews, details of forthcoming events, and the option to sign up for our newsletters.

Bloomsbury books may be purchased for business or promotional use. For information on bulk purchases please contact Macmillan Corporate and Premium Sales Department at specialmarkets@macmillan.com.

For Deborah Chambers, 'La Catalana',
whose kindness and support has meant so much

# PROLOGUE
## BEHIND THE FAÇADE

Gaudí, possibly more than any other architect in history, has been totally misunderstood. Many people take Gaudí's buildings at face value. They wonder wide-eyed at the audacity, the orgy of colour, the engineering brilliance and outrageous daring, the sensuous surfaces that invite a touch, the wild and wonderful subject matter of dragons and skulls and the gingerbread-style houses made as if copied straight from the nightmare pages of Grimm's *Hansel and Gretel*. What they often fail to do is look behind the seductive, sometimes frightening, façade.

Of all of Gaudí's buildings, the Sagrada Família – a true life's work – is by far the most puzzling and the most quixotic. Its ambition seemingly knows no bounds, and its complex narrative is as mystifying as the visions that Saint John recorded on Patmos, which were later transformed into the Book of Revelation.

For the reader expecting a standard guidebook with an easy route to follow, and some simple observations followed by the odd suggestion for what else to see, this is not for you. The Sagrada Família is already so well publicised, so often visited, so often photographed that as *the* icon for Barcelona, it appears to need no introduction. That is, of course, a wholly simplistic approach to Gaudí's fantastically complex 'cathedral'. For more than a century, the

'real' Sagrada Família has somehow managed to success-
fully hide itself behind the blinding glare of the spotlight
out there in full public view.

If Gaudí's buildings were misunderstood, so was he.
Gaudí as a man was a fascinating catalogue of contradic-
tions: he was both revolutionary and deeply conser-
vative; massively ambitious yet also humble; at the cutting
edge yet deliberately medieval; pig-headed and irritable,
yet also patient and kind; he was almost the epitome of the
Franciscan – happiest when meditating and communing
with nature; yet he was also a passionate Catalan national-
ist but, paradoxically, at the same time always reaching out
towards the universal in his aspirations and ideals. Catalan
identity is often described as representing the complex
fusion of the two creative extremes embodied in the dia-
lectically opposed concepts of *seny* and *rauxa* – cold com-
mon sense, versus sometimes explosive outbursts. Gaudí
was all of this and more.

Part of the reason for dismissing Gaudí so easily as a
mere theatrical showman is partly his own fault, or rather
the fault of his sheer approachability. For many years,
Gaudí was deemed far too popular and lightweight for
architectural historians – outside of Catalonia – to take
him seriously. He was also seen as far too eccentric, too
bizarre and, in Catalonia, the land of Salvador Dalí, almost
too obviously surrealist and actually downright strange.

Gaudí is a total one-off. But Dalí's obsessive interest in
Gaudí did the architect no favours. In 1933 in the surrealist
magazine *Minotaure*, in an article entitled 'The Terrifying
and Edible Beauty of Art Nouveau Architecture', Dalí
eulogised, rhapsodised then sacrificed Gaudí's architecture

on the altar of his own perverse ego. As always, Dalí was far cleverer than he gave himself credit for. Gaudí's architecture was sensual, soft, erotic, inviting touch. It was like an ornamental 'confectioner's table', Dalí said, and he was right – it does have the faint echo of those great *pièces montées* of chocolate, icing and spun sugar constructed by the legendary Antonin Carême for the banquets of tsars, kings and emperors. It was Carême – the first superstar chef – who, puffed up with the pride of his profession, made the rather silly claim that 'architecture was the most noble of the arts and that pastry was the highest form of architecture'. However, even today Christian Escriba, Catalan's celebrated chocolatier, is known to construct and carefully mould the odd version of a Gaudí house in chocolate in direct homage to his two masters, the two Antonis, Carême and Gaudí.

It's no secret that Ferran Adrià, the world's most famous chef, has also frequently looked to Gaudí for inspiration.

But Adrià's adulation goes right to the crux of the Gaudí problem. Seduced by the surface, we are less likely to look behind the scenes. And this is where Ferran Adrià can help us out. Because what we see in Adrià's extraordinary culinary creations is a search for the science and the hidden structures in the nature of food. And by digging even deeper, Adrià, like Gaudí, is hell-bent on the labyrinthine search for the source of creativity itself.

Dalí's support for what he saw as the 'delirious' architecture of Gaudí certainly touched a raw nerve. Gaudí is popular, massively so. He gives joy – *fa goig*, as he would say in Catalan. But the joy that Gaudí gives comes at the cost of his suffering, of rigorous self-discipline, of painstaking

research, and also by the grace of his engineering genius. Finally, of course, right at the centre of his work sits his profound Catholic faith like a hard kernel, inviolate and unbreakable. The Sagrada Família is so unique, and so closely associated with Barcelona, that it is often forgotten that it grew out of a pan-European Catholic revival.

In an age when we are so often told that religion is dying, except, of course, when it manifests itself as a good reason for going to war, it is perhaps strange that a building project on the scale of the Sagrada Família still continues to forge ahead.

The Sagrada Família is a unique project that is slowly reaching its long-awaited end. If all goes to plan, the gigantic dome, which will double the existing building's height, will be topped out in 2026 to celebrate the centenary of Gaudí's death. Like the construction of all churches, it is really in the end that we find the beginning. And the Sagrada Família will be no exception.

What I hope to offer the reader is an insight into the creative genius that is Gaudí: to trace the development of the Sagrada Família's evolution from expiatory temple to basilica, and open a window onto its complex Christian narrative. It is a fascinating story that started with the dreams of an eccentric Barcelona bookseller in the mid-nineteenth century to find a way of celebrating the life of the holy family. Today we witness the near completion of this extraordinary high-tech build. From beginning to end there have been planning battles, misunderstandings, and an alleged attempt to blow it up, and, of course, the tragic death of Gaudí — run over by a tram en route to the ritual of his daily confession at Saint

Felipe Neri, down in the old Gothic quarter of Barcelona. Finally, the Sagrada Família's special status has now been fully acknowledged and celebrated with the consecration of the building by Pope Benedict XVI himself.

That Gaudí was way ahead of his time is now broadly accepted. Strangely, there were few disciples in Spain, but he did prove inspirational for the Latin American boom of organic architects such as Oscar Niemeyer and Felix Candela. Today, his style and revolutionary new techniques have also proved highly influential for a new generation of 'starchitects' like Frank Gehry, Zaha Hadid and Santiago Calatrava, or the lesser-known 2015 Pritzker winner Frei Otto, a thesis confirmed convincingly by just the briefest sideways glance at almost any of their buildings. At Gehry's iconic Guggenheim museum in Bilbao, or Calatrava's less well known winery in Laguardia, the undulating forms and the natural rhythms of the progressive waves of titanium and steel are inspired by the pebble that Gaudí dropped in a pond more than 130 years ago.

I

'Mathematics is the alphabet with which God has written the universe'

*— Galileo Galilei*

Standing patiently in the long queue to enter Antoni Gaudí's Sagrada Família is the best method of understanding its extraordinary appeal.

There are other ways of entering through the security barriers without the long wait (advanced bookings on the internet, for instance). But the queue's effect of slowing us down forces us to realise the pilgrimatic nature of our visit. And it gives us time for reflection. We can begin to look more keenly at the exterior detail while at the same time familiarising ourselves with its dramatic silhouette. Our eyes are caught first by the gigantic cornucopia of exotic multicoloured fruit that crown each pinnacle sparkling in the sun, and seem the product of some mad scientist's latest GMO trial to provide sustenance for a feast of the gods. There are builders' cranes everywhere, crisscrossing the skyline as the vertiginous towers push skyward as if released by the power of a geological eruption.

The building's overwhelming scale immediately imposes itself and acts to diminish us and put us in our place. It is disquieting, uncomfortable and even just a little terrifying.

We quickly, despite our reserve, feel the need to swap impressions with our neighbours. We need to register and compare our degree of being completely overawed.

A cursory glance down the ever-lengthening queue tells us more about the Sagrada Família's universal appeal and the power of advertising than any opinion poll. The day I chose to wait proved no exception. Two down the line a scholarly Italian – with the trademark lemon-coloured cashmere draped over his shoulders – craned studiously over his partner's head, with binoculars pushed hard to his face. A bit too loudly, he whispered his excitement in her ear: first workout of the day for his strained neck muscles. It was obvious he was awestruck by the workings of the gigantic construction cranes – the tallest in Europe. I bumped into him later, staring up, still caught in a trance. He was not a professor; it turned out he owned a *trattoria* in the shadow of Bologna's *cattedrale*, from where he could feel the earthquake rumbles of *La Nonna*, with its three-ton bell. Bologna may have Europe's oldest university and many other reasons for civic pride, but for this Bolognese, it was the Sagrada Família's vast space that had impressed him most. A giant sounding box! He pushed me his card: 'If ever in Bologna, come enjoy some good hearty food. *Mi casa tu casa.*'

Nearby in the queue was a family just flown in from Australia who brought with them a different architectural DNA, and an entirely different set of expectations. Their benchmark for 'awesome' was Jorn Utzon's iconic Sydney Opera House, crowning Bennelong Point, the cathedral-like space constructed from what appears as a cluster of cracked giant emu shells or the gigantic sails of a clipper as

it noses slowly out into the harbour. This suggests a more contemporary set of aesthetic desires, already hotwired to accept novelty, drama and radical innovation. Would Gaudí surprise? Yes, he certainly would, and did — followed by a collective sharp intake of breath — as the Australians prepared to share their extraordinary experience.

Further down the line I could see groups of Japanese and Koreans who seemed to love Gaudí like a religion and needed no persuading at all as to the Catalan master's abiding genius. There were half a dozen French visitors waiting patiently just beyond — just a few of the more than half a million who cross the Pyrenees to visit Barcelona every year. Everybody, of course, brings with them their individual architectural yardstick and measures of excellence. For the Muscovites their ideal of theatrical is that glorious orgy of colour that decorates the swirling onion domes of Saint Basil's cathedral on Red Square. It is a vision from an exotic, oriental world that looks distinctly Byzantine, as if bringing to life visions from the Book of Revelation.

For visitors from Qatar and the Gulf States could anything begin to rival or appear as audacious as their construction industry's 24/7 relentless swallowing-up of the desert, and land reclamation from the Persian Gulf? Or, for that matter, compete with the ultimate show-off luxury of Dubai's seven-star resort hotel, the Burj Al Arab, in the United Arab Emirates? It's hard to imagine. But even Muslims, Buddhists from China, and Hindi speakers from the Indian subcontinent, fed on a daily diet of the Taj Mahal, the Great Wall or the breathtaking discovery of Emperor Qin Shi Huang's 6,000 terracotta warriors, make the pilgrimage to gaze at Gaudí's Catholic shrine,

as they allow their respective religions to briefly take a back seat.

On any single day a quick stroll down the visitor line outside the Sagrada Família will throw up more than twenty first-language groups and that doesn't include the native Catalans, Spaniards, Basques and Galicians. It is a veritable united nations of people that feels the need every year, in ever-increasing numbers, to visit the miracle that is Gaudí's – and the late nineteenth century, the twentieth century, and the twenty-first century's – longest ongoing building project. Why do they come? And what do they know about Gaudí?

Almost all will fall into the elementary mistake (I still do) of describing it as Barcelona's cathedral. It isn't. Down in Barcelona's Barri Gòtic – its perfectly preserved Gothic quarter – stands the predominantly Gothic cathedral of the Holy Cross and Santa Eulalia, which actually took almost five times longer than the Sagrada Família's still-ongoing construction to complete – 700 years, or even longer, depending on whether you include its pre-Romanesque roots.

In today's computer age the *vox populi* is most easily found on TripAdvisor, where the basilica of the Sagrada Família comes in as Barcelona's most-visited destination, out-voting the old Gothic cathedral by a ratio of twenty to one. The most frequent descriptions are the stock responses of 'awe', 'awesome', 'unique' and 'wonder', while others go for 'psychedelic', 'Disneyland' and 'fairy-tale'. There are dissenting voices, of course, that pick up almost exclusively on the inevitable fallout of mass tourism: the crowds, the queues, the rudeness, the

mushrooming up of the generic Starbucks and Subway, the tourist shops selling plastic rubbish, the Swarovski bling, the creamy kitsch ceramics by Lladró, the Messi football shirts sporting the Qatar Airways logo, and the inevitable Irish pub offering the *craic*. It's hard to tell whether Lionel Messi's recent choice of a Sagrada Família-inspired tattoo, which runs from his upper arm to his wrist, is more than just a tribal display for the Barça dressing room to show off his love and affection for his newly adopted city. As a homage, I doubt it does the project any favours. The choice of image, however, is telling.

Surrounded by the merchandise, there are some prepared to criticise the Sagrada Família on the grounds of bad taste, while others are still confused by the variety of styles. And inevitably, there are a few who take umbrage with so much money spent on an extravagant building while beggars starve out in the street.

It has always been thus.

During the Spanish Golden Age of architecture, which spanned the fifteenth and sixteenth centuries, Spain habitually spent – year in, year out – around 10 per cent of its GDP on works of art, cathedrals, churches, convents and luxurious tapestries that celebrated the Catholic faith. That level of expenditure was deemed absolutely normal; a political imperative, which, it goes without saying, functioned as a hugely effective form of propaganda. By 1900, spending patterns had changed and the empire had gone. The debate and tensions between church construction and charity had now come to the fore.

In 1898, the little known 25-year-old artist Joaquim Mir produced a wonderfully emotive painting of

the Sagrada Família. Mir's vision provided a perfect snap-
shot of Gaudí's work-in-progress, shot through with fire-
bursts of lemon-coloured light and the deep saffron hues
of the setting sun. Years later, Mir would become recog-
nised as the 'Van Gogh of Catalonia' — and that in a gen-
eration which boasted stars of the stature of the brilliant
Santiago Rusiñol, Ramon Casas and, last but not least, the
genius Pablo Picasso.

Mir's painting, later known as *La catedral de los pobres* —
the *Cathedral of the Poor* — focuses our eyes immediately on
what appears to be a ruin under restoration, a romantic
folly or a building in construction. The strong *sol y som-
bra* contrasts play the orange, which fires up the walls,
off against the sudden white glare of freshly cut blocks of
stone in the middle distance. In the left foreground, cast
in shade, we recognise a mother worrying over her sleep-
ing baby, an exhausted elder daughter has collapsed against
her knee, while the father holds his hand out begging for
alms. It is a picture of sad resignation, pathetic yet star-
tling with the brilliance of light pulling us back to Gaudí's
masterpiece. But it is the man's imploring gaze, coming
out from the shadows, that continues to haunt us and con-
tinually draws us back in.

It is an awkward, embarrassing encounter, which reveals
as much as it hides. With further investigation we can find
an elderly couple, perhaps the extended family, behind the
beggar, and in the far distance behind the two stonemasons
a briefly sketched-out procession as it snakes towards the
church.

So what are we actually looking at? In the background
we see the Sagrada Família surrounded by cranes, much

as we do today – a building site. Of course, since Mir's detailed study a great deal has changed. From 1898 to the present day, work on the Sagrada Família has continued almost without a break. The world around it has changed dramatically. When the first stone was laid in 1882, there were no cars, computers, laser distance meters or state-of-the-art sky-high cranes, just horse-drawn carts, plumb lines and mechanical pulleys that had changed little since the early Middle Ages and were used even earlier still, more than two thousand years ago, during the life of Christ, when the Romans developed the castrum and port of Barcino.

Joaquim Mir's focus on a builder's yard is perhaps a curious choice of subject. It is deliberately unheroic, perhaps best described as a masterpiece of social realism. Yet what does it want to tell us? Is the Church about to offer help to this unfortunate family? Mir's observation is desperately contemporary, as relevant when painted as it is today. We will never know whether Mir's vision is ironic, satirical, critical or just a work of pure observation. Mir's vision is also carefully coded. Growing just behind the group is a young tree, tied to a stake. Youth needs guidance, it seems to say. Is this simply what it seems – a plea to observe the faith?

A preparatory sketch by Mir for *La catedral de los pobres*, recently acquired by the Museu Nacional d'Art de Catalunya (MNAC) casts doubt and deeper shadows.

In the sketch, the Catedral de los pobres stands further back; a distant silhouette in the wastelands and far-flung suburbs of a hungry, expanding industrial Barcelona. The optimism and warming light of the painting gives way to

graphic, sketchy detail. There's more acid, more distance and less humanity.

The family of beggars – with no suggestion here that they might be stand-ins for the Sagrada or the holy family – are sidelined. Instead it is the long line of the sad flotsam and jetsam of the modern world, with their life's possessions swinging on the end of a pole, that grabs our attention. Bent double under the weight of rejection and failure, the procession seems to go on forever. Significantly, it bypasses the church.

The year 1898, the date of Mir's picture, would prove catastrophic to Spain and Catalonia; the dispirited intelligentsia who would become known as 'the Generation of 1898' were forever traumatised by the events of that year. The dramatic defeat of the Spanish in Cuba, in the six-week-long Spanish–American War, meant the immediate return of the wounded, the disenfranchised, the defeated, and thousands of nuns and priests whose missionary work was no longer required. Beggars and desperate starving amputees were everywhere. On every church step in Barcelona, as Mir documents so well, the victims held out their hands.

What Mir could never have predicted in 1898 is that his painting *La catedral de los pobres* would become an early pictorial record of the transformation of those huge lumps of stone into the foundation blocks for a building, whose ambition, both material and spiritual, was towards creating the Third Millennium's greatest Temple to God.

From 1883 until his death in 1926, Gaudí devoted the majority of his time to the Sagrada Família. For the last decade of his life it won his exclusive attention. Nothing

else mattered as he fought continuously to realise his vision in stone.

'If it was Gaudí who built the Sagrada Família,' one churchman observed, 'it was also the Sagrada Família that made him the devout Christian that he would finally become.' And there is a very real truth in that, with some going even further to make special claims for his singularity and his exemplary ways.

For more than twenty years the Association for the Beatification of Antoni Gaudí has actively pursued the future beatification of the devout Catalan architect. To avoid the inevitable confusion, it's worth briefly laying out the process by which Gaudí might eventually be declared a saint.

Rarely is sainthood bestowed on someone quickly. Saint Peter of Verona, who was killed by a Cathar assassin's pruning knife in the thirteenth century and yet still had the composure and strength to write down the first words of the Nicene Creed – *Credo in unum Deum* – in his own blood, holds the all-time record at under a year. Hard on his heels was the great thaumaturgist – miracle-worker – Saint Anthony of Padua, the Hammer of the Heretics, whose oratorical skills bewitched the fishes in the river and whose tongue glistened *incorrupto* thirty years after his death. But these remarkable men were both exceptions that proved the rule. Following on from their fast-track precedents, the recognition of sanctity became slower and slower, until now it almost always inches forward at a snail's pace.

Sainthood is a long, complex process that is tested at every stage, first by the local church, and then, in Gaudí's

case, by Barcelona's archbishop and his advisors, to pass finally under the scrutiny of the Vatican's Congregation of the Doctrine of the Faith, amongst other Catholic institutions. The aim of the process is to achieve beatification as the first step towards eventual canonisation, with Saint Antoni Gaudí recognised as the first patron saint of the arts. En route Gaudí's status would therefore progress logically from Servant of God, where testimony of his virtues is collected and placed before the Congregation for the Causes of the Saints, through the elevated title of Venerable, followed by Blessed and, finally, Saint. At each stage there are checks and balances and an elaborate process that requires proofs of virtues and, most importantly, proofs of miracles.

Brought up within the United Reformed Church (a predominantly Calvinist fusion of the Protestant Church), I confess that this is a foreign land to me. But, once again, where Gaudí fascinates is that his personality and his body of work accretes around it almost medieval values and concepts of faith that some see as distinctly unfashionable and others wholly reject, but that are nevertheless right at the heart of our notions about faith. That miracles happen, we all know. How we place them in our belief system or what value we place on them is another question altogether.

The most useful route for me as a non-Catholic, but as a student of the faith as it relates to Spanish art, has been through the rigorous documentation of miracles in Spain from the thirteenth to the twentieth century by the extraordinary religious historian William A. Christian Jr; a well-deserved recipient of the coveted MacArthur 'Genius

Grant'. Through a string of titles that includes *Apparitions in late Medieval and Renaissance Spain*, *Visionaries* and *Person and God in a Spanish Valley*, Christian has catalogued, analysed and struggled to make sense of thousands of miracles over the ages.

Donning the multiple hats of historian, anthropologist, psychologist and sage of popular folk mythology, William A. Christian Jr offers trenchant advice to the sceptical or hostile cynic. The least interesting thing about a miracle, suggests Christian, is whether it's true; that is, after all, merely a matter of faith. Through their tendency towards developing tropes, inevitable repetition and cliché, we see in miracles both the imagination in full flight and its obvious limitations. Miracles, for instance, the recurring apparition of a half-size Virgin Mary to a shepherd girl on the borders of a Castilian village, can be read in many ways. A wild boar going to ground on a king or nobleman's hunting trip only to reveal the existence of a long-hidden relic or a sacred image is another frequent 'type'. Miracles are, in a sense, social barometers and, like lightning poles, they attract useful data that can bear witness to the anxieties and aspirations of their age.

The religious personality and appeal of Gaudí's architecture, and specifically the Sagrada Família, has resulted in numerous instances where people have felt the need to thank the architect for his intercession. If Gaudí was, in the words of Folch i Torres, a 'miraculous architect', and in the opinion of the artist Joan Llimona 'one of the chosen few', it is not surprising that the faithful, when tested, should turn to him.

Some of the letters received by the Association of the Beatification of Antoni Gaudí have an arresting honesty and simplicity to them.

Is it entirely surprising that in times of catastrophic economic crisis, the devout Gaudí is thanked again and again for helping close relations find employment, a roof over their heads or a reprieve on a defaulted mortgage? Or, on a more prosaic level, that Andreu Català, the son of the famous photographer Català Roca, should credit Gaudí with helping him find a lost camera lens, still in perfect condition, six weeks after he had dropped it 90 metres from a Sagrada Família construction crane? Weighted carefully, the evidence provided by miracles, even if dismissed by harsh critics as nothing more than wish fulfilment, nevertheless adds a rich seam to the history of cultural mentalities. In Gaudí's case, there are further claims for successful intercession in the treatment of intestinal haemorrhages, lumbar scoliosis, paralysis, cataracts and for serious depressions, as well as brain tumours, kidney transplants and near-fatal heart attacks. The most moving testimonies are from two apparently contradictory witnesses to Gaudí's powers of intervention. One woman prayed to help release her husband from the appalling calvary that is acute Alzheimer's, while another prayed for a full recovery from the curse of the age that is cancer. Both found solace and an answer in their prayers to Gaudí and the sympathetic timetable of Divine Providence.

What is clear is that the wish for Gaudí's beatification and the continuation of the Sagrada Família build is part of a greater spiritual project spearheaded by Cardinal Lluís Martínez Sistach, Archbishop Emeritus of Barcelona, who

retired in 2015. Cardinal Martínez Sistach is a key player within the Vatican hierarchy and in 2012 acted as one of the Synod Fathers promoting the New Evangelisation. For the cardinal, one of the great projects of our time is to attempt to overcome 'religious illiteracy' by returning to the Romanesque model of the early Middle Ages, when art played an absolutely central role in faith, and society as a whole.

For Martínez Sistach it is not mere chance that the two great façades of the Sagrada Família – the Nativity by Gaudí and that of the Passion, started in 1986 by the hugely polemical sculptor Josep Maria Subirachs – face outwards onto the street like two giant altarpieces inviting the passer-by to dwell on the Christian model. Cardinal Martínez Sistach's affection and ambition for the Sagrada Família runs far deeper than that, as his book *La Sagrada Família, un diálogo entre fe y cultura: un icono para la Iglesia del siglo XXI*, suggests.

As with all of Gaudí's work, the surface disguises a deeper reality. The temple's engineering and the cohesion of the intricate and interlocking structure is a perfect metaphor for a profound reflection on the complex Catholic liturgy and the structure of the Christian year. Contemplation of this complex edifice would slowly reveal, Gaudí hoped, a pathway towards a deeper spiritual truth.

Placed as it is in the centre of urban Barcelona, the Sagrada Família has transformed the city, argues Cardinal Sistach, and therefore fits perfectly into the model for the new evangelising movement, Mission Metropolis. Pushing aside the Fritz Lang associations of man and the machine, Mission Metropolis is a project that links Barcelona into

a twelve-city network with Budapest, Brussels, Dublin, Cologne, Lisbon, Liverpool, Paris, Turin, Warsaw, Vienna and Zagreb. Like the twelve disciples, the New Evangelisation is set on a proactive path to make up lost ground by reclaiming lost souls, born in the Church, who have fallen prey to apathy, agnosticism or atheism within the boundaries of old Europe. New Evangelisation's analysis of the present crisis in faith has suggested the evolution of two distinct strands to the movement. One is Mission Metropolis, and deals with lapsed or 'lazy' Catholics, and the other reaches out to those of other creeds in an ecumenical way. Both based on dialogue, the second, more testing project, entitled the Courtyard of the Gentiles, modelled on King Herod's refashioning of the Temple of Jerusalem, focuses on creating spaces where dialogue between all the faiths, including with non-believers, is possible in a peaceful and respectful way. Set up by the Pontifical Council for Culture under the presidency of Cardinal Gianfranco Ravasi, who wrote the prologue for Cardinal Martínez Sistach's book, the Courtyard of the Gentiles fits in with Pope Francis's belief in supporting the Franciscan spirit of meaningful outreach. According to Cardinal Ravasi, it is important that we should look to the example of the first-century Jewish–Hellenistic philosopher Philo of Alexandria, who working 'at the boundary' of his faith, had his eyes and ears open to those who walked outside its walls. For Cardinal Ravasi, it is imperative and essential that we are brave enough to 'grasp the flower of dialogue'.

For Catalonia, whose spiritual life is built so solidly on the foundations of the thirteenth-century Doctor

Illuminatus Ramon Llull, who dedicated his life to converting Muslims to Christianity, the proposition of hosting the Courtyard of the Gentiles is not entirely strange. With regard to Gaudí, there is the added coincidence that Ramon Llull, centuries ahead of his time, was also one of the godfathers of computation theory, which would prove so central to the scientific rationale of Gaudí's working model for the Sagrada Família.

For Cardinal Martínez Sistach, the Sagrada Família, with its universal appeal, its revolutionary style, its blend of the medieval with the modern and the exemplary life of its creator Antoni Gaudí, makes it a perfect focus point for these different evangelising strands. For the city council of Barcelona, whose success in promoting the tourism industry has threatened to make it a victim of its own success, the attraction of the Sagrada Família might also help with decongesting the old Barri Gòtic and the Ramblas by tempting the tourist away and spreading the impact over a larger footprint. Cardinal Martínez Sistach believes the most important aspect of the Sagrada Família is not its impact on city planning but instead its extraordinary spiritual reach, which, he argues, makes it a worthy recipient of the ambitious title 'the Cathedral of Europe'.

If the Catalan Catholic hierarchy is keen to focus on Gaudí's pedigree as a worker of miracles, an idea that some find difficult to sympathise with, there are nevertheless many more mundane and practical reasons for attaching the adjective 'miraculous' to the Sagrada Família. From the laying of the first stone on 19 March 1882 up until today, the Sagrada Família has continued to build its way through a long litany of conflicts, disasters and very

real threats to its continued existence. Despite the almost weekly explosions of anarchist bombs in the late nineteenth century in central Barcelona, the Sagrada Família project also managed to survive the terrible fallout of the disastrous 1898 Spanish–American War, the convent and church burning of the 'Tragic Week of 1909', the horrors of the First World War, the Great Depression, the Spanish Civil War, the Second World War, the Cold War, the war on terrorism, and the catastrophic financial meltdown of the early 2000s. It is almost certainly the only building project in existence that was started in the nineteenth century and is still being built today. And, despite everything, it has remained surprisingly contemporary and enormously influential.

For Gaudí, there was a real virtue to be made out of the necessity of building at such a measured pace. Grasping a metaphor from nature, he likened the Sagrada Família's slow evolution to the growth of a mighty oak that could withstand all the winds of change. In contrast, the growth spurt of the humble bamboo that grew in the *maresme* and the flash-flood riverbeds meant that they were flattened by the first *xaloc*, the fierce Saharan wind that blew up the Catalan coast. With a client as patient as God, what was a mere 150 years in comparison to cathedrals like Barcelona and Seville, which had taken close to 500 years to complete?

Let's try to see the slow pace of building of the Sagrada Família from a different perspective, by relating it back to the revolutionary visual art of its time – in both painting and sculpture.

As the first stone was being laid, Edouard Manet was putting the finishing touches to his final masterpiece, *A Bar*

*at the Folies-Bergère.* With the rapid speed of change in the world of modern art, Manet's disquieting vision already seems to have come from another age when lorgnettes, top hats and silver-topped canes were still all *de rigueur* – the world of Gaudí's youth.

In his prescient paean to modernity Manet had deliberately focused on the social dislocation and the commodification of sex that found its profoundest expression in the model's detached gaze, as she stands before us, hands on the bar, framed by bottles of champagne and a bowl of oranges: compliant, resigned and essentially bored. Waiting. Dressed decorously in her figure-hugging black velvet jacket fringed with lace, her choker and exotic corsage, she has become objectified, and appears sadly lost. Manet's brilliant essay in *ennui* represented exactly what the Sagrada Família was designed to combat: the loss of self, the loss of traditional Catholic values and the faith's reverence for the family enshrined in the Virgin Mary, whose Immaculate Conception had been elevated into dogma only thirty years before. According to many Catholic analysts, the industrial revolution had drained the lifeblood out of modern man and leached out the humane from humanity itself.

In startling contrast, just two years after Manet had painted his secular masterpiece, Nietzsche, in his philosophical novel *Thus Spoke Zarathustra*, had questioned the very validity of faith and pronounced with a historic sense of finality that, once and forever more, 'God is dead.'

The juggernaut of scientific rationality had dramatically increased its velocity with Darwin's earlier publication of *On the Origin of Species* in 1859, an extraordinary thesis that

by implication questioned a literal reading of Genesis and God's centrality to creation.

Gaudí, in direct contrast, had been building from the ground floor up, gradually evolving his theory of architectural creation based on a deep study of what he called 'the Great Book of Nature', where nature's structures, as observed in sinuous snake skeletons, ribcages, springtime shoots, and the gnarls and knots on oak trees that bore witness to their struggle for growth, revealed what was, for him, not the absence but the omnipresence of God's guiding hand.

In the field of sculpture, Auguste Rodin – the most famous artist since Michelangelo and Bernini – had just embarked on his monumental tour de force, *The Gates of Hell*, which reached back to the visions of an earlier age. Inspired by the terrifying images described in Dante's *Inferno*, Rodin's masterpiece, commissioned in 1880 – two years before the Sagrada Família – would still remain unfinished on his death in 1917. Like Gaudí's uncompleted Nativity façade at the Sagrada Família, its overwhelming ambition had tested out Rodin to the very limits of his creativity.

If the Sagrada Família was begun just as impressionism was beginning to find favour and lose its revolutionary cutting edge, it has since outlasted every other 'ism' that came after those beguiling early investigations into the nature of light. From post-impressionism through Fauvism, the groundbreaking revolution that was cubism, and onwards through futurism, surrealism, abstract expressionism, conceptualism, post-modernism, and on out into the wild uncharted beyond, the Sagrada Família has continued to rise up as if oblivious to all the changing styles and fashions

in art. In relationship to the recent history of architecture, the story of the Sagrada Família's resilience is even more remarkable.

Within Gaudí's lifetime, before he was tragically run over by a tram in 1926, his work had already begun to fall out of fashion. Indeed, even the Sagrada Família's future hung in the balance as Gaudí had been seen out on the streets with a begging bowl looking for funds. As the *Modernista* style, which Gaudí helped pioneer, quickly became passé, it was rapidly replaced by the more rational classical Mediterranean aesthetic of *Noucentisme*. Little known outside of Catalonia, *Noucentisme* was soon swamped by a revolution in architecture on a global scale. In 1929 the Barcelona International Exposition, the brain-child of Gaudí's rival, Josep Puig i Cadafalch, opened on Montjuïc to huge acclaim. Populist touches like Utrillo's Poble Espanyol – a recreation in reduced format of Spain's regional monuments – and the cascading Magic Fountain set off the grandiose *palau* crowning the hill, provided a perfect example of overblown historicism mixed with shameless pastiche.

It was Ludwig Mies van der Rohe's stark German pavil-ion, however, that potentially rang the death knell for Gaudí's organic style. Van der Rohe showcased the elegance of the International Style's spare, lean and hard-edged aes-thetic. Glass and steel would be the style of the twentieth century – emptiness its mother tongue. The new temples were not going to be Christian cathedrals crammed full of religious narrative and unnecessary distraction, but rather the pristine white box of the museum, of which the Museum of Modern Art in New York, inaugurated the

same year, in November 1929, would become the perfect exemplar. Reflection and transparency were now the new ideals.

The success of the radical International Style's transformation into the new Catalan orthodoxy threatened the Sagrada Família's very existence. The new generation of Catalan architects were led by Antoni Bonet Castellana and the brilliant Jose Lluís Sert. Both had been heavily influenced by Le Corbusier and would work with him in Paris. Under the umbrella of the architect collective GATCPAC – Grup d'Arquitectes i Tècnics Catalans per al Progrés de l'Arquitectura Contemporània – they set the new agenda, sweeping aside the stuffy over-decorated Victorian interior to declutter our space. Stained-glass evocations of the bucolic Catalan flora and fauna, and especially the telluric olive tree and the mythic *azahar* – orange blossom – had been central to the *Modernista* aesthetic of Gaudí, Domènech and Puig, with its deep-seated feeling of *enyorança* – nostalgia – for a bygone age. In stark contrast to the prevalent romanticism, GATCPAC wanted to look into the future through the widest panes of unclouded glass.

By the end of the nineteenth century, Barcelona had started to look north to Paris for inspiration, where the artists Zuloaga, Casas, Rusiñol and Picasso and the trio of composers Granados, Albéniz and de Falla found a spiritual home. Paris provided a haven for the avant-garde and the philosophy of continuous experiment. But it was also in Paris that the state of sacred architecture, and its future, received the most blistering critique.

Totally unexpected was that the most hard-hitting and withering analysis would come from within the confines of the Catholic Church.

After the First World War, it had become obvious that the world had descended into a profound spiritual crisis. And so too had the state of official Catholic art, which had become mired in a swamp of saccharine sentimentality. Academicism, the 'official' Catholic style, was at best theatrical, but was often hollow and wooden and slipped all too easily into full-blown kitsch. According to the philosopher Jacques Maritain, there needed to be a genuine Catholic enquiry into the meaning of modern art rather than a frightened, almost paranoid rejection.

The source for much of Catholic hysteria and fear was traced back to Pope Pius IX's 1864 *Syllabus of Errors*, which saw modernity, rationalism, liberalism, religious toleration, Freemasonry, socialism and communism as responsible for society's decadence. In much the same vein, despite the interim liberalising trend of Leo XIII, Pius X demanded as late as 1910 that all priests with pastoral duties had to sign the 'Oath Against Modernism' – a retrograde imposition that could only encourage a schism within the Catholic Church.

For Maritain this head-in-the-sand rejection of modernity and the 'official' reactionary and retrograde celebration of the art of the Middle Ages could only produce an empty, cliché-ridden, soulless art that was not relevant to contemporary society and the trauma it had recently suffered. The millions of dead that lay buried in mass graves after the First World War, the more than 20 million that perished in the great flu pandemic of 1918, led a

traumatised generation of survivors to seek solace wherever they could. What Maritain saw as the way forward for the Catholic Church was best exemplified by the painters Maurice Denis and Georges Rouault, who in his opinion successfully married faith to modernity while remaining true to their inner selves and producing a genuine and most importantly *cathartic* art.

It was at Maurice Denis's Ateliers d'Art Sacré that the young philosopher and stained-glass artist Marie-Alain Couturier would find his vocation. In 1925, despite his obvious passion for his *métier,* Couturier entered the Dominican order and immediately renounced his art. Encouraged by his superiors, Couturier – after a period of profound reflection – returned to his art with a heightened zeal and a new sense of religious focus.

Couturier would become a leading light in the movement of the Catholic revival – *renouveau catholique.* Rejecting the negativity and sterility of the ultramontane conservatives, who held on desperately to the certainties of the *Syllabus of Errors*, *renouveau catholique* fought fiercely for an art and architecture that might revive the sense of community and faith of the Middle Ages but in a thoroughly modern idiom.

Couturier pulled no punches. In his in-house magazine *L'Art Sacré*, he analysed the dreadful malaise of the era:

It was an unbroken tradition: century after century it was to the foremost masters of Western art, diverse and revolutionary as they might be, that popes and bishops and abbots entrusted the greatest

monuments of Christendom, at times in defiance of all opposition. From Cimabue and Giotto to Piero, from Masaccio to Michelangelo and Raphael, from Tintoretto and Rubens to Tiepolo, that tradition of courage and mutual confidence was kept alive. The most powerful currents of Western art had never been diverted from the Church.

With the nineteenth century all this began to change. One after another, the great men were bypassed in favour of secondary talents, then of third-rates, then of quakers, then of hucksters. Thereafter the biggest monuments were also the worst (Lourdes, Fourvière, Lisieux, etc.).

In the conservative Catholic hierarchy and those with their vested interests in the draw of the remarkable Saint Thérèse of Lisieux, canonised in 1925, and the visions of the innocent peasant girl Saint Bernadette, canonised in 1933, this could have been read as politically uncomfortable if not as outright heresy.

A few years later Couturier was even more outspoken. Reporting to his fellow Dominicans, he argued:

Our church art is in complete decay . . . It's dead, dusty, academic – imitations of imitations . . . with no power to speak to modern man. Outside the Church the great modern masters have walked – Manet, Cézanne, Renoir, Van Gogh, Matisse, Picasso, Braque. The Church has not reached out, as once it would have, to bring them in. And here we have men who speak directly to the people with the same simple power of the great artists

of the Middle Ages . . . These moderns are greater than
the sensual men of the Renaissance.

Was Gaudí's Sagrada Família going to become yet
another addendum to Couturier's long list of etceteras,
like the shrine at Lourdes and that other disaster in 'taste',
Paris's overblown Sacré-Cœur?

Or was Gaudí the genius that might stem the tide?

The Sagrada Família is certainly *not* an imitation of an
imitation, however one describes it.

Whether it has the power to speak to modern man can
only be judged with hindsight.

Today, with almost 4 million paying visitors a year, and
the many, many more who stop and stare from outside
the perimeter gates, it suggests that Gaudí's invention is
touching a chord.

Does it have the simple power of the great artists of the
Middle Ages? The question is too complex to come to an
easy and immediate conclusion. The Sagrada Família itself
is of such an overwhelming complexity that it tests to the
limits our powers of logic, comprehension and even the
strength of our faith.

Couturier's track record in religious commissions has
stood the test of time. It was his intervention that smoothed
the path for Le Corbusier's great sweeping masterpiece,
the chapel of Notre-Dame du Haut in Ronchamp; perhaps
the work in which 'Corb' is most indebted to Gaudí. With
Corbish wit, the organic roof sweeps up skywards like the
crisply starched form of a nun's wimple. At Notre-Dame
de Toute Grâce in Assy he would work with the Catholic
artists Bonnard and Rouault. And true to his convictions

and his belief that genius and genuine engagement was the ultimate gauge, he called in the communists Léger and Lurçat to add to the ensemble.

Spirituality, according to Couturier, was sometimes purer in those who walked outside the walls of the Church and who questioned their beliefs than in those who were comfortable in their establishment faith. 'This fact may be irritating, but at the present time it is undeniable. The Spirit breatheth where the Spirit will.'

In the choice of his commissions Couturier remained as ecumenical as the message he voiced. Jewish artists like Lipchitz and Chagall received the Dominican's largesse.

'Does it worry you that I'm Jewish?' asked Chagall. 'Does it worry you?' Couturier replied.

Couturier's open attitude didn't go unnoticed. In keeping with the other pious, Pope Pius XII in his November 1947 encyclical *Mediator Dei* stated the Vatican view: 'Modern art should be given free scope in the due and reverend service of the Church and the sacred rites, provided that it preserves a correct balance between styles, tending neither to extreme realism nor to excessive "symbolism", and that the needs of the Christian community are taken into consideration rather than the particular taste or talent of the individual artist.'

Who had Pope Pius XII lined up in his sights? According to William Rubin, the pope was looking the Dominicans straight in the eye.

'We cannot help,' Pius XII continued, 'deploring and condemning those works of art, recently introduced by some which seem to be a distortion and perversion of true art and which at times openly shock Christian taste.'

Pushing Pius XII's certain sense of appropriate taste briefly to one side, Couturier's greatest achievement was without a doubt his involvement with Matisse's breathtaking La Chapelle du Rosaire in Vence, as powerful and spiritual in its way, and as intimate and ultimately human, as Gaudí's remarkable crypt at the Colonia Güell . . . both true, distilled, harmonious and extraordinary works of genius.

As early as the thirteenth century, Saint Thomas Aquinas, arguably the most important Dominican thinker, and beloved by Gaudí, had developed in his *Summa Theologicae* a concept of the beautiful in art: 'Three things are necessary for beauty: first, integrity or perfection, for things that are lacking in something are for this reason ugly; also due proportion or consonance; and again, clarity, for we call things beautiful when they are brightly coloured.'

It is against this backdrop that we should see the continuation of Gaudí's Sagrada Família after the architect's death in 1926. How did the Sagrada Família measure up to Aquinas's concepts, concepts that Gaudí held dear to his heart? And how did the Sagrada Família measure up to Couturier's demands for an art that married faith to modernity? Less important, but certainly central to the debate, was whether the Sagrada Família would have passed the rigorous examination of Couturier's connoisseur's eye. Would it have been to his taste? Or could he fathom the rhyme and reason that lay behind Gaudí's revolutionary new style?

If style and taste were the only criteria for judging the Sagrada Família, it might never have continued as long as it has. Riding the waves of fashion and keeping up to date

with the fleeting nature of its ephemeral styles was never Gaudí's aim, just as good taste had never been at the top of his agenda. Dissecting the aesthetics of modernism was still a generation away. In 1939 the self-appointed pontiff of modern American art, Clement Greenberg, published his seminal essay 'Avant-Garde and Kitsch', in which he argued that late-nineteenth-century art had become polarised between an avant-garde that tested the limits of expression and a kitsch that provided a shallow pastiche and a general 'dumbing-down'. His real enemy, however, was what both he and Couturier understood as academic art. Greenberg, belligerent as always, pronounced provocatively: 'All kitsch is academic, and conversely, all that is academic is kitsch.' Kitsch, according to Greenberg, was nothing more than 'vicarious experience for the insensitive'. In many ways Greenberg's essay redefined the ideas of the Spanish philosopher Ortega y Gasset, who had earlier decried the woeful art of the 'mass man' and called for an elite culture that celebrated 'the high noon of the intellect'. What both men concluded was that there existed high and low art and good and bad taste. What they didn't allow for was the seriousness and singularity of Spanish religious art. While Ortega favoured irony and whimsy, Gaudí sought out the solid ground of faith and the common touch.

The question that the tradition of Spanish religious art throws up is on one level very simple: does it work? When praying to an image, however vulgar, or pleading for inter-cession, does it provide solace? The question is not one of taste, good or bad. Gaudí's genius lay like Picasso's (who, incidentally, despised Gaudí's buildings and all that he stood

for) in his capacity to marry the most genuine and revolu-
tionary invention with the simplicity and naïveté of popu-
lar art. One of the main reasons for the Sagrada Família's
incredible appeal is not just the thrill of the spectacle but
its – at a superficial first glance – total accessibility.

The reason for its longevity is altogether different.
Started in 1882, like so many worthy Victorian-era monu-
ments built on the proceeds of a public subscription, the
Spiritual Association of the Devotees of St Joseph has
entered the new millennium with a Sagrada Família that
sets the all-time record on the modern-day phenomenon
of crowdfunding. All who visit the Sagrada Família are
implicated, by dint of their entrance fee, in this extra-
ordinary project.

For almost 140 years people have continued to pay to
visit what until very recently was essentially a building site
and they almost always leave astonished and bewildered by
the virtuosity and ambition of the Gaudínian style.

Their curiosity and generosity has always meant far
more to the Catholic Church and to Gaudí. The Sagrada
Família was set up as an expiatory temple so that sinners –
all of us – might recognise their sins and come to terms
with them by pleading for forgiveness. Sometimes the
relationship between sin and forgiveness can be entirely
practical.

In return for their entrance fee and the visitor's com-
mitment and curiosity, the magazine *El Propagador de la
Devoción a San José* listed the payback, via indulgences, that
was favoured by subsequent popes. Under the contro-
versial Pius IX, whose *Syllabus of Errors* had so uncom-
promisingly condemned the heresies of secular society, those

who donated to the devotees of St Joseph, even before the building works had begun, could expect – in exchange for their admission fee – an apostolic blessing and 100 days' indulgences.

Under his successor, the reforming Leo XIII, whose groundbreaking encyclical *Rerum novarum* of 1891 had so trenchantly highlighted the growing polarity between wealth and the working class, to the detriment of the latter and society as a whole, visitors to the Sagrada Família could expect only an apostolic blessing. Leo XIII's successor Pius X – returning to the earlier style – promised to the Sagrada Família's visitors an apostolic blessing and fifty days' indulgences; whereas Pius XI, returning to Leon XIII's earlier example, assumed that an apostolic blessing would surely suffice.

What all popes recognised was the growing appeal of the Sagrada Família and the increasing devotion to the architect-high priest Antoni Gaudí.

In 1927, a year after the architect's death, it was still just possible for *El Propagador* to list those who had donated by name, send them a thank-you card, and list the number of visitors who had requested the services of the official guide. Two Poles, eight Danes, three Turks, two Yugoslavians and four intrepid Costa Ricans had availed themselves of the service in the month of February.

Today, with the Sagrada Família's universal appeal, that number would be easily replicated in the first five minutes of a quiet Monday morning, as more than 10,000 visitors queue up every day – come rain or shine.

Back in 1927, the advice to visitors was clear. Take the tram and avoid at all costs the coach drivers and chauffeurs

who, posing as scholarly 'cicerones', 'know nothing of the truth of the grand construction'. Only the official guide, according to *El Propagador*, was capable of understanding the building's material structure and transmitting the power of its true spirituality. And, like today, when the most-visited parts of any large country house are the kitchens, the highlight of the tour was always the workshops where Gaudí's plans and models still littered the space. Tragically, in 1936, after the first few days of the Spanish Civil War, Gaudí's studio was left a burnt-out empty shell. For today's curious visitor the workshops below the Sagrada Família are now far closer to a research laboratory, where computer models extrapolate from the surviving fragments how the work should continue for years to come.

This is what we might describe as 'the archaeology of the future'. But it might also be useful to use the Sagrada Família as a window to throw light on the dim and distant past. Despite its modernity, the Sagrada Família draws much of its identity from the Middle Ages and earlier still. Looking up at its skyline, the Sagrada Família appears both state of the art and futuristic, while paradoxically reminding us also of those iconic representations of the exotic multi-turreted celestial city on earth that is Jerusalem, as visioned in those millennial early medieval *mapamundi*; both ancient and new.

Our initial reaction to entering the Sagrada Família's soaring space gives us an indication of what it might have felt like to encounter for the first time some of the architectural wonders of the world. To have walked the streets of Rome in the middle of the second century AD and step

into the Pantheon, with its massive dome and open oculus constructed from super-strength concrete with its secret ingredient of Pozzolane Rosse ash collected from the sulphurous Alban Hills, must have been, for the innocent viewer, just totally staggering.

To have crossed the Bosphorus in the sixth century AD and enter Byzantium's overwhelming Hagia Sophia, the largest church in the world for a thousand years, must have imprinted on the viewer the immense power, prestige and the long geographical reach of Christendom. Likewise, in the same century, to have crossed the desert in modern-day Iraq and entered under the incredible vault of the imperial palace at Taq-i Kisra, in the ancient city of Ctesiphon, must have been mind-blowing.

In total contrast, to have disembarked on the quays of Cordoba at the other end of the Mediterranean – Europe's back door – around the first millennium, and entered the Great Mosque with its apparently endless lapidary forest of columns appearing slowly in the half-light, must have been incredible. It would have bewitched, disoriented and terrified the Christian visitor in equal measure.

What these amazing dream palaces and temples to polytheism, Christianity and Islam all shared was a genius for innovation. What they also shared was the ability to shock and inspire awe.

Gaudí understood this. As he also understood the seductive power of beauty when cast in the shade by the terror of the sublime. In his 1757 *Philosophical Enquiry into the Origin of our Ideas of the Sublime and Beautiful* Edmund Burke had argued that 'the passion caused by the great and

sublime in nature. . . is Astonishment: and Astonishment
is that state of the soul, in which all its motions are sus-
pended, with some degree of horror'.

On Gaudí's death only the unfinished Nativity façade
could give a true impression of what he hoped to achieve.
Dwarfed by its scale as it leans out over our heads, this
Catalan cosmos threatens to crush us with the unlimited
power of God. It is like coming face to face with one of the
most dramatic Wagner opera sets at Bayreuth, in its ambi-
tion to become the total surround-sound *Gesamtkunstwerk*
(the total work of art). What future generations of archi-
tects following Gaudí's death have given us in the Sagrada
Família's interior is a judicious contrast needed to make
sense of the whole.

Walking back through the entrance, as I have done a
hundred times before, the effect is as fresh, startling and
powerful as if seeing it for the very first time. If the exter-
ior's sublimity 'tightens these fibres', as Burke would have
us believe, then the glorious soaring interior lifts the spirit
in response to the pain. The interior is a revelation. A reve-
lation that Gaudí's central achievement at the Sagrada
Família is to simultaneously defy and recognise the power
of gravity, as the building's skin appears punctured by the
ethereal nature and divinity of light.

To enter the Sagrada Família is like walking into a giant
skeleton with its articulated joints swelling up to lift the
vertiginous space ever higher. Everywhere you look there
are rhythmic abstract patterns. The mosaic detailing cre-
ates an atmosphere that is somewhere between Gustav
Klimt and the neo-Egyptian style of the 1920s, a reworked

echo of the art deco style. Up in the vaults starburst cap-
itals seem like teeth almost literally chewing away at the
space. But everywhere large patches of colour are cast
onto the stone through stained-glass windows of an aston-
ishing chromatic brilliance. Higher still, a clearer light is
literally funnelled and sucked in through domes whose
elegant organic shapes are reminiscent of giant elongated
egg timers pushing up and penetrating the protective skin
of the roof.

Looking up at the roof's complex vaulting structure
reminds us almost immediately of an inverted egg box.
One could be facile and play out the chicken and egg
conundrum by asking which came first: the egg box or
Gaudí? (Part of the answer to that question is that Joseph
Coyle, a newspaperman from British Columbia, designed
the egg carton in 1911, after an argument with a local
farmer.) Joking apart, the egg-box observation is also
highly instructive. The egg, whose structure and symbolic
power Gaudí fully recognised, is one of nature's most
powerful shapes, yet also extremely fragile. Egg cartons
are designed in moulded cardboard to be resistant, robust,
flexible, light and economical, allowing always for an
infinitesimal yet often considerable variation in the size
of the egg. Egg cartons, however humble and overlooked,
are geometric masterpieces of design. Reproduced by
now in their billions, they are in their way as satisfying
as the intricate carved plaster *muqarnas* ceilings of the
Alhambra that Gaudí took papier-mâché moulds of as
a student for the Philadelphia Centennial exhibition in
1876, right at the beginning of his career.

Whose childhood, one may well ask, has not been enriched by the totally absorbing creative ritual of carving up an egg carton using just a pair of scissors?

What is genius? One possible answer is that genius is the capacity to ask the simple question and worry it to death. Isaac Newton, whose studies on gravity Gaudí knew from top to bottom and inside out, described his extraordinary vision with disarming humility: 'I was like a boy playing on the sea-shore, and diverting myself now and then finding a smoother pebble or a prettier shell than ordinary, whilst the great ocean of truth lay all undiscovered before me.'

Newton shared with Gaudí a lifelong interest in the Book of Revelation. And both men shared a belief in the divine genius of the creator. 'Atheism is so senseless,' observed Newton. 'When I look at the solar system, I see the earth at the right distance from the sun to receive the proper amounts of heat and light. This did not happen by chance.' Neither was it merely chance, Gaudí argued, with more than a hint of chauvinistic pride, that Catalonia was the appropriate place to create an architectural *masterpiece*.

Just off the meridian, Gaudí's birth city Reus, south of Barcelona, enjoyed the perfect latitude, which meant it received the ideal light – falling at forty-five degrees – for reading, interpreting and quite literally feeling and caressing our way around sculptural volume – for seeing, if you like, the shape of an egg.

Gaudí's understanding of the shaping power of light, if visceral as a youth, became increasingly biblical as he grew older.

Gaudí's real revelation, however, came like Newton's – from observing the world at work. It was a Pauline

moment that for Gaudí would transform him forever into the godfather of what one critic has described as 'bio-mimetic architecture'.

Holding up a linked chain between his two hands, Gaudí observed how it fell in a curving loop. If inverted, the curved loop was transformed into what has become known as a catenary arch. An arch that stood on its own, without buttressing or the need for support and both structurally fantastically efficient and superbly economical on its architectural stress. It was a simple model that would always lie at the heart of Gaudí's work and become his signature leitmotif. And with that model right at the core, Gaudí hoped to build higher towards a heaven on earth.

'Originality,' Gaudí once famously said, 'means returning to the origin.' And it is to the origin we must go: to find the four-year-old Gaudí, suffering from crippling rheumatoid arthritis, distracted in his private world by the incessant sound of the drumming cicada that disturbed his siesta, as later at dusk he would be mesmerised by the magic of the glowing fireflies, as the planets and stars set up their show, ready to take centre stage in God's firmament to reveal to us 'heavens' embroidered cloths'.

On the borders of the small village of Riudoms, in Catalonia's Baix Camp, where his father had a workshop, young Gaudí played along the flash-flood riverbed observing nature in all its myriad forms; in all its strange geometries and intriguing manifestations of natural engineering as it sprang irrepressibly into glorious life.

There have been many heated exchanges over the years debating Gaudí's birthplace. The facts, as we know them, state that Antoni Gaudí was born on 25 June 1852. Having recently lost two children, Gaudí's anxious parents, Francesc and Antonia, as a precaution, immediately took him to the church of Sant Pere Apostol in Reus to be baptised; a perfectly normal practice for traditional God-fearing Catholics.

Whether he was born in the family home on Carrer Sant Joan in the provincial city of Reus (nineteenth-century Catalonia's second city) or, as other people argue, at his father's workshop the Mas de la Calderera a few kilometres away seems of little consequence to the dispassionate outsider. Stuck out amongst the undergrowth of the dried-out flash-flood riverbed – the Riera de Maspujols – the make-do Mas de la Calderera is on the outskirts of the neighbouring village Riudoms. It seems highly unlikely that Antonia would have risked a bumpy mule-drawn carriage ride out to her husband's workshop in the last week of her pregnancy. For those claiming kinship to a potential future saint, however, these small but important details really matter, and understandably so. The diplomatic solution to this thorny dispute, and the most likely conclusion, is that Antoni Gaudí was almost certainly born in Reus. If we accept this, we should also move forward and recognise

that it was the flora and fauna of Riudoms that gave him the major inspiration for his extraordinarily rich creative life.

Much is made of the central importance of childhood games in the formation of the creative mind. A great deal of stress is placed on that moment of revelation when play becomes truly inventive and inspirational. As a young boy suffering from rheumatoid arthritis, Gaudí was frequently transported by donkey to the Mas de la Calderera for rest and recuperation. While there, he became an inquisitive and avid watcher of everything around him. Lying in the shade or scrambling through the undergrowth he could chase lizards, watch the perilous scorpion arching up its threatening tail, listen to the ceaseless drum of the cicada and start to recognise the rhythms and patterns of nature. Throughout his life the Baix Camp would remain a reference point, with its seemingly endless vineyards and stands of hazelnut, almond and olive trees rising slowly up towards the *serra*. Set against the dramatic backdrop of a cerulean blue sky, it represented to the adult Gaudí a childhood Eden.

In the history of architecture the most famous example of childhood play informing adult practice is that of Frank Lloyd Wright. When Gaudí was exhibiting his papier-mâché copies of the Alhambra at the Philadelphia Centennial, Frank Lloyd Wright's mother, Anna Lloyd Jones, was there at the huge exhibition buying for her gifted son another foreign import, a set of the famous pedagogue Friedrich Fröbel's building blocks. These simple hard-edged shapes transformed the young Frank's way of seeing and feeling space. Looking back, he would reflect that 'these primary forms and figures were the secret of

all effects . . . the maple-wood blocks . . . are in my fingers to this day'. And Frank Lloyd Wright would, throughout his career, transform architecture, remaining loyal to the infinite potential and variety of those cubes, rectangles, triangles, pyramids and the straight lines he found in Fröbel's bricks.

Gaudí's architectural kindergarten was radically different, organic and almost entirely devoid of the straight lines that would regiment Frank Lloyd Wright's imagination. For Gaudí, a dried-out snake skeleton, bending slowly round, might give a masterclass in articulation. Trees, it appeared to the novice eye, seemed to shoot out their branches in apparently random patterns; while ants worked in teams lifting staggering weights; and far out at sea cloud formations, if you learnt to read them, signalled oncoming storms. Weathered sandstone beaten by wind and waves appeared almost molten as nature manifested its extraordinary transformative power.

When straight lines appeared in nature they were there for a purpose. The hexagonal honeycomb (one of Gaudí's enduring motifs) provided a lesson in creating the most efficient form for maximising the contact between contiguous surfaces, as the worker bees artfully created a natural air-conditioning system to keep the queen perfectly cool in her brood comb under the heat of the midday sun.

Down in the scrubby undergrowth, a beetle's glorious carapace shone like a jewel, while behind it the slow snail dragged along its towering home. Gaudí was transfixed by the delicate fern fronds that moved with the wind, and watched as the blossoms burst and the date palms pushed out their fingers; the full cornucopia of rival plants fighting

for their corner like buildings shouting for attention in a tight city grid. Little could Gaudí know that his childhood visions would soon find a scientific explanation in the seminal masterpiece written by Sir D'Arcy Wentworth Thompson *On Growth and Form*, in which the Scottish scientist elucidated his universal theory of morphogenesis — the natural evolution of a shape.

Just a short walk down the *riera* brought Gaudí to the Mediterranean seashore, where in the rock pools he could study the transition from land to sea as the push and pull of water smoothed off the pebbles and ate out the rock, providing hiding places for the molluscs, starfish and crabs. On the sand, the washed-up shells seduced him with their intricate spirals and whorls. Tests of dried-out sea urchins, their calcareous shells divided neatly into five, revealed on their nubbed surface nature's propensity for producing symmetrical patterns as elegant as any ceramic bowl. Desiccated sea cucumbers and the curling seaweed displayed other amazing details, as did driftwood and weathered bark. Looking closer, Gaudí could wonder over the veins in a leaf; the swelling crown of an artichoke; the swollen knuckles of the towering bamboo; the skeletal structure of the ubiquitous prickly pear; or, better still, the spiky aloes' spiralling growth and the glorious head of a rogue sunflower blown across from the fields nearby, both perfect examples of the complex Fibonacci sequence and Fermat's spiral of primes. As incredible, and eerily majestic, was the tensile strength revealed in the spectacular architecture of a spider's web; at its most beautiful at first light when illuminated by droplets of morning dew, it created an ephemeral illusion of a kaleidoscope

or the rainbow burst of a cathedral's stained glass. Like
Isaac Newton, Gaudí was a devil for detail, trusting above
everything empirical evidence, especially when dressed up
with beauty. None of these lessons were lost on Gaudí.
Absolutely nothing was wasted. From the earth to the stars
Gaudí had the images engraved into his imagination until
he knew where they might fit. From the cosmic to the
banal, everything added grist to the mill. Almost fifty years
later, the motifs and subjects that he had captured during
his childhood would reappear with a dramatic realism on
the façade of the Sagrada Família; even a full-size sardine
boat, complete with lantern, was later transformed by
Gaudí into stone.

If this was what Gaudí would later describe as 'the Great
Book of Nature', it still needed a structure to underpin it
and make sense of the whole. Youthful wonderment might
in adulthood seek out scientific explanations, or look fur-
ther back to the search for spiritual meaning first proposed
by Saint Isidore in his *Etymologiae* or Saint Ildefonsus in his
*De progressu spiritualis deserti*, where everything in nature
might be read as a symbolic reminder of Christ's teachings
and his sufferings on earth. In Gaudí's personal evolution
as an architect in service to the Church, Charles Darwin
and D'Arcy Wentworth Thompson would have to be
pushed to one side to make space for the theory of genesis
and the omnipotence of God. Just as Gaudí's keen sense
of observation would have to find a way of translating all
that he had seen in his youth into the creation of a new and
revolutionary language of form.

In this respect, nothing for Gaudí compared to the first-
hand experience of watching his father fashion seductive

shapes in the white heat of the forge. A skilled fabricator of brandy stills, Francesc carefully computed the correct volume of a copper alembic as flat surfaces were hammered out, pulled, beaten, encouraged, teased and gently stretched out into their entirely practical yet satisfying three-dimensional form. For the adult Gaudí working on the Sagrada Família, it was the combined DNA of eight generations of craftsmen ancestors that would always lead him to favour working with architectural models rather than poring over sterile 2D plans. For him, like his father, space and volume were properties that had to be felt with the hand and measured by the eye. Plans, at the end of the day, were mere abstractions that automatically put the architect at one remove.

Like many geniuses before him, Gaudí was a student whose progress in school was nothing out of the ordinary. He excelled in geometry but remained average in almost everything else. He had a romantic strain – not fixated like so many on the beautiful young female Reusencs – but instead focused on Catalonia's history as he shared with his classmates Toda and Ribera their fantasies and dreams of ruins and the restoration of Catalonia's glorious past. The three teenagers, fired up, actually embarked on an attempt to restore the abandoned Cistercian monastery of Poblet. In the scant dozen issues of their own school magazine *El Arlequín* the trio showed themselves to be exemplary followers of the new Catalan renaissance, the *Renaixença*.

Starting as a predominantly romantic movement, the *Renaixença* soon came to reflect the dynamism and diversity of an increasingly self-confident industrial Catalonia. Recovering the values and energy of Catalonia in its heyday

during the Middle Ages, Catalan epic verse was celebrated in their poetry olympics – the *Jocs Florals* – as choral societies abounded and the popular *excursionista* groups focused on rediscovering abandoned architectural jewels hidden in the high Pyrenees. Firmly nationalist in inspiration, the *Renaixença* as a cultural movement was immensely attractive to the likes of Gaudí and his friends, who would follow its evolution from its liberal beginnings towards a greater conservatism as the movement matured. Already deeply imbued with a love of Catalan nature, Gaudí was easily seduced by the growing tendency in architecture that was to blossom into the Catalan art nouveau equivalent known as *Modernisme*. The hallmark of *Modernisme* was the introduction of nature into the city as decoration and distraction, employing stained glass, wrought-iron detailing, mosaic, carved plaster and sculpture. Underpinning the architectural *Modernista* style were the imported ideas of Pugin, Ruskin, the architectural theorist Viollet-le-Duc and William Morris's reverence for handicraft and decoration, which naturally touched a deep chord in Gaudí. However, as we will see, he was never hidebound by the conventions of a particular style, his originality and genius was precisely his willingness to break the mould. He would outgrow the *Renaixença* just as he would leave the *Modernista* style behind. We should remember Gaudí's enduring mantra: 'Originality meant going back to the origin.' And the origin, for Gaudí, was the family land in Riudoms, where nature posed those profoundly complex problems whose solutions he would slowly divine.

First, most importantly, Gaudí needed an architectural education. And it is of huge symbolic importance

that his father Francesc, a key member of Reus's *menes-tral* – artisan class – was prepared to sell his land, his par-cel of Catalan *terra*, to pay for both Gaudí and his elder brother, a medical student, to study in Barcelona. The lessons learnt at the Mas de la Calderera would have to pass through the crucible of a rigid and traditional train-ing to see if the sought-after originality had the strength to survive.

Gaudí arrived in Barcelona in September 1868 at a pro-pitious moment. Madrid's central government had finally capitulated and Barcelona, after centuries of being strait-jacketed within its medieval city walls and living in the shadow of the imposing Ciutadella fort, was allowed to plan its modern *eixample* – extension. The radical urban planner Ildefons Cerdà provided a perfect model for Barcelona's inevitable growth. His egalitarian grid plan, with its clearly socialist aspirations, despite them later being watered down, nevertheless represented a revolu-tionary new beginning. Coupled with this, Gaudí's fellow Reusense, General Prim, the Conde de Reus, in the same month as Gaudí's arrival in the city had successfully forced the Bourbon queen, Isabella II, into exile in what quickly became mythologised as 'the Glorious Revolution'. It was a brief honeymoon that ended with Prim's assassin-ation just two years later, resulting in the installation of an interim First Republic that in turn was soon replaced by a return to the Bourbon crown. But the optimism brought in on the wings of the short-lived Glorious Revolution was best reflected in the boom in transportation, textiles, ship-ping, steel, and especially the construction industry, which was further boosted by Barcelona's privileged access to

the Cuba trade and the explosion of the *Indiano* traders' wealth.

With three years left at secondary school, and a further three in preparatory studies at Barcelona University, Gaudí had the opportunity to absorb his new surroundings and study the rich architectural fabric of Europe's largest surviving Gothic quarter. One of the finest examples of Catalan Gothic, built during the fourteenth century, was the neighbouring parish church of Santa María del Mar, affectionately known as the Cathedral of the Ribera. The purity of its spare Gothic style could not help but impress itself on Gaudí's youthful mind, just as its build philosophy of a shared communal and Christian effort would resonate with Gaudí when finally he was offered the commission of his life.

On 24 October 1874, 22-year-old Gaudí enrolled at Barcelona's recently inaugurated architectural school. In many ways the state of architectural education reflected the revolutionary dynamism of Catalonia as a whole. Diversity of possible sources for inspiration exploded in the magazines, international exhibitions, trade shows and travellers' photo-reportage as Spain and Catalonia celebrated their unique and colourful past. But behind all the novelty there had to be a guiding rationale. Viollet-le-Duc without a doubt provided the driving logic:

We must find this creativity through an accurate knowledge of the works of our ancestors. Not that such knowledge must lead us to imitate them slavishly, but rather it will reveal and make available all the secret

skills of our predecessors. No doubt the very multiplicity of these skills makes their use today difficult. But when you discover these secrets lying behind the finest works in the bosom of the highest and most beautiful civilisations, you quickly recognise that all these secrets can be reduced to just a few principles, and that as a result of the sort of fermentation initiated when they are combined, the new can and must appear unceasingly.

The late nineteenth century was nothing if not the age of eclecticism, cultural colonialism and the art of pastiche. But what might Gaudí borrow from these? The Catalan Gothic was perhaps the most celebrated. The Romanesque, as seen in the monumental masterpiece of the portal of Santa Maria de Ripoll or the humble Capella d'en Marcús just around the corner from where he lived with his brother Francesc, was another source for inspiration. Roman remains abounded, as too did the eighteenth-century *sgraffito* exteriors that were so seductive to the eye and accompanied the neo-classical style with their wonderful plaster-carved putti, cornucopia, swirls, curlicues and endless decoration. From photographs he could easily appropriate the exotic, the eccentric, the ancient and new. He could immerse himself in the monumental, the religious or the seemingly infinite range of vernacular styles. There was perhaps a surfeit, even an orgy, of available possibilities.

What Gaudí really needed most was the armoury provided at architectural school by studying perspective, mechanics, hydrological engineering, stress, graphic statics, topography, mechanics and the selling of a project to a

client with exquisite preparatory drawings. Gaudí baulked at much of the pedestrian, often repetitive teaching; but it was definitely advisable to reject from a position of knowledge, rather than one of ignorance that would almost certainly result in a failed exam.

In 1878, Lluìs Domènech i Montaner published in *La Renaixença* his hugely influential essay 'In Search of a National Architecture' in which, amongst other things, he highlighted the unique legacy of Islamic architecture to the storehouse of Catalan taste. As a teacher in the architectural school, Domènech, just two years older than Gaudí, was in a position of authority. An organisational genius, he was also a publisher, architect, book designer, author, expert on heraldry and future director of the Barcelona School of Architecture; and finally as a politician he would become president of Catalonia. As a scion of one of the *gent de bé* – the good families – and *hereu*, heir to the dynasty, he was connected in a way that Gaudí could only dream of. Most importantly, he would remain a rival of Gaudí's throughout his life until his death in 1923. While the rivalry remained professional, and arguably brought out the best in both architects, their differences proved telling.

Gaudí's strength of character, which he himself recognised as a liability, was what finally set them apart. None of the easy *entrées* afforded Domènech came as a given to Gaudí. He fought for his connections and at times must have suffered from acute loneliness, especially over a period of two months, in 1876, when the trauma of his brother Francesc's death, the *hereu*, was quickly followed by the death of his mother. Just three years later, his sister Rosa

died. Gaudí's gift was to discover strength in adversity and transform suffering into a cathartic positive quality. Where Domènech was blessed with an easy social route to a client base – which in no way denigrates his incredible talent and extraordinary work ethic – Gaudí had to take on jobbing assistant work for other teacher-architects. It would prove a blessing.

Qualifying as an architect, finally, in March 1878, and with no one in his family circle available to come up with his first commission, Gaudí picked up small projects, including a set of lamp posts for the Ayuntamiento – still in place today in the Plaça Reial – and for a never-completed flower-stall for the Ramblas that bizarrely doubled up as a urinal. Other manifestations of his burgeoning talent included his visiting card, his work desk and a refit for the Farmacia Gibert on the elegant Passeig de Gràcia. It was just enough to pay the rent and be able to return to see his grieving father Francesc in his home town Reus with his head held high; but with little more to offer than optimistic promises of future success. Contacts came slowly and often by chance. But when they did, they were certainly the very best he could expect.

At the 1878 Paris Expo his display stand for the glove manufacturer Comella caught the attention of Don Eusebi Güell, a self-made multimillionaire industrialist with immaculate taste and enough wisdom to keep his ambition discreetly under wraps. Whether the chemistry was immediate is impossible now to say, but it would prove the ultimate partnership. Güell was generous with his connections and passed Gaudí on to the Marquès de Comillas (whose daughter would marry into the Güell

clan), who commissioned from Gaudí a set of religious furniture for his private chapel in Comillas in 1880. The following summer, in preparation for a royal visit, Gaudí designed for Comillas a wildly exotic glass gazebo, as a one-off extravaganza, which was, in architectural terms, just one up the ladder from a party tent. In Barcelona he had also been absorbed into the architect Juan Martorell's design team for the Jesuit college in Carrer Casp and for the church of the Salesian brothers. Coupled with commissions for an altar at San Andrés del Palomar and the chapel of Jesús y María, closer to home in Tarragona, Gaudí's expanding religious portfolio was beginning to appear like a speciality. These commissions were, as is so common in the architectural profession, just the ones that saw the light of the day. There were many that never got off the drawing board: lighting for Barcelona's harbour wall, a church altarpiece, and designs for a fashionable country estate in Gelida. A small theatre in Sant Gervasi de Cassoles was completed but was forgotten almost immediately.

One project proposal, however, was fascinating. Under the guidance of Juan Martorell i Montells, the god-father of Catalonia's Gothic revival, the dream team of Martorell, Domènech and Gaudí was brought together to enter the competition for the final façade of Barcelona's Gothic cathedral, which had remained unfinished almost 500 years on. If there were difficulties or personal rivalries to overcome, the businessman Manuel Girona hoped they might pull together and come up with a happy solution. Despite its obvious promise, the project unfortunately and inexplicably stumbled at the first hurdle.

The fantasy union of these three talents, which spanned
the generations, however, revealed a far more complex
web of connections. If Gaudí had picked up the furni-
ture commission for Comillas, and Domènech the reli-
gious Universidad Pontificia, it was the more conservative
and established Martorell who, through his seniority and
sobering influence, was rightly judged to be the safer pair
of hands. Martorell was rewarded with the Marquès de
Comillas's Sobrellano Palace and more significantly the
family's Chapel Pantheon. The small village of Comillas,
on the northern Cantabrian Atlantic coast, was to be trans-
formed into a showcase and haven for the latest Catalan
*Modernista* style. The construction of a Catholic university,
however, signalled that Comillas's avant-garde pretensions
to modernity were modulated by an orthodox Catholic
world view. Although Gaudí was clearly the lesser partner
in creating the new Comillas, it nevertheless represented
a fantastic opportunity to associate himself with the elite
of his profession and forge a deeper relationship with the
Comillas-Güell clan.

In Spain and Catalonia the ties of friendship that arise
from being brought up in the same village or town are
extraordinarily strong. It is almost as if geography itself
defines the strongest social group after or sometimes even
before the nuclear family itself. Although occasionally
described as eccentric, shy and pig-headed, Gaudí was no
exception to the rule that placed a premium on familiarity,
loyalty, trust and cooperation. Whether it was at the chess
tables of the Ateneu or through a mutual friend, the poet
Joaquim Bartrina, that Gaudí met his next client, Salvador
Pagès i Anglada, is not known but, importantly, they both

hailed from Reus. A generation older than Gaudí, Pagès i Anglada had founded the textile business the Sociedad Cooperativa La Obrera Mataronense in 1864, in the small workers' town of Gràcia on the borders of the Eixample. Within a decade, the success of the pioneering cooperative, clearly built on the legacy of English and Scottish utopian models, demanded a new factory in the town of Mataró, just fifteen kilometres north on the coastline in the fertile plain of the *maresme*. Most importantly, as the larder of Barcelona, Mataró was linked by direct railway to the expanding metropolis as early as 1848, the first in the Iberian Peninsula. Pagès i Anglada's visionary project needed an architect sympathetic to his ideals, prepared to be original, and almost certainly cheap. Gaudí fitted the bill. It is interesting to note that at the same time as Gaudí was forging his friendship with Güell, he was also being courted by a potential rival whose philosophy might seem radically at odds. Few young architects looking for work can afford principles if they want to see their drawing-board fantasies realised at all. What is clear from Gaudí's reaction, however, is that he responded to Pagès i Anglada's brief with immense sympathy.

The factory complex of La Obrera Mataronense included all the various industrial buildings: fulling mills for cleaning the wool, thread stores, bleaching halls for the cotton, the perimeter security walls, a garden, a café-clubhouse, meeting rooms, the quaint workers' latrines in the shape of a pillbox, a porter's lodge and housing for thirty staff. As his first large-scale project, it demanded all Gaudí's attention, and was to last five years. He was joined in the studio by a partner, Emili

Cabanyes, who as Mataró's town architect was busy planning its own *eixample* in partnership with the celebrated civil engineer and poet Melcior de Palau, whose claim to fame was sealed in 1878 by translating into Castilian Spanish the poet-priest Jacint Verdaguer's prize-winning epic *L'Atlàntida*, which had just taken the *Jocs Florals* by storm. (Gaudí, just a few years later, would transform the mythical Atlàntida into bricks, mortar, adobe and stone for his client Eusebi Güell.)

As interesting as the building project for La Obrera Mataronense was, the business also needed, in Pagès i Anglada's opinion, a full-scale corporate rebranding. Through a proper marketing strategy and the fashioning of a holistic identity they hoped to focus on their cooperative philosophy and their novel systems of work. Although Pagès i Anglada's textile cooperative and the future Sagrada Família seem at first glance diametrically opposed, it is surprising how the similarities begin to surface if you just scratch at the skin.

Both the Sagrada Família and La Obrera were paternalistic and perhaps overly didactic; especially when scrutinised by the standards of today's taste. On the factory walls Gaudí painted encouraging uplifting slogans such as 'Comrade, be sound, practise kindness!' and the wonderfully innocent, 'Nothing is greater than fraternity.' Patronising advice that might best be described as the idealistic morphing of a utopian tract and a self-help motivational manual or the result of a brainstorming session at a corny 1950s management seminar.

'Do you wish to be an intelligent man? Be kind!' it was further suggested. Unusually, the workers were also

encouraged to think out of the box as they were warned that 'Too much courtesy is proof of a false education'.

If La Obrera was a laboratory test that aimed to improve the quality of the working man, the Sagrada Família focused on saving his soul.

The symbolic metaphor that Gaudí found for La Obrera Mataronense was the image of the worker bee. Over the years it would develop as a leitmotif for many of his other commissions, where sweet honey and drudgery provide the perfect recipe for social success. On the cooperative banner and La Obrera's official stationery letterhead the bees buzzed backwards and forwards as if magically working the looms.

In the opinion of an early biographer, César Martinell, Gaudí always remained true to his early fraternal support for the honest working man. Not surprisingly, it was in the craftsman that he always recognised both the vision and integrity of his father, Francesc. But, of course, as Catalonia changed around him and the conflictual relationship between labour and the means of production increased – and as violent anarchism took firm hold – Gaudí subtly shifted his position. According to Martinell: 'In later years he retracted his liberal ways, but he never abandoned his labourist ideals, though he did cease to flaunt them. What he did was to substitute Christian charity for secular philanthropy.'

Today La Obrera Mataronense is a shadow of its former self. Many of the houses were never built as planned and the factory was finally abandoned. Gaudí's most important building, the bleaching shed, has been recently restored to its former beauty and now houses

the Bassat contemporary art collection. Inspired by Barcelona's fourteenth-century Saló del Tinell, where Columbus allegedly offered Ferdinand and Isabella the Americas on his return, and other civic buildings like the great medieval boatbuilding yards, Gaudí went for the same spacious effect at a fraction of the price. Covering 600 square metres with one roof, Gaudí avoided the use of columns and load-bearing walls by creating grand semi-circular arches formed out of a three-plank-thick laminate carefully bolted together. It is a stunningly simple solution to a complex brief.

During the summer of 1882, while still deeply involved in his collaboration with Emilio Cabañes at Mataró, the greatest commission of Gaudí's life – the Sagrada Família – had started without him.

In retrospect, it's not surprising, considering that Gaudí had little more to show prospective clients than an unfinished factory, some lamp posts, a shop refit, a glass gazebo, a never-produced flower-stall-cum-urinal and some religious furniture. The Sagrada Família's junta – board of works – could hardly have sanctioned even interviewing an architect with such a spare curriculum. It needed a miracle or a stroke of fortune for Gaudí to get a foot in the door.

Almost no visitor to the Sagrada Família follows the correct route in.

The mistake is understandable. What we want is instant gratification. We need to be immediately dazzled and bowled over by the glorious triumph of Gaudí's spectacular space in order to satisfy our craving for novelty. But it really does pay to hold back, and take the opportunity to take a slow walk back in time and study the building's genesis. By starting with the explosive beginning we deny ourselves the remarkable drama of its gradual flowering and growth.

Chronology here is of cardinal importance. It was the crypt, deep below the altar, that came first. But it is also essential, if we want our encounter with the Sagrada Família to be profound and meaningful, that we descend into the crypt to pay homage at Gaudí's shrine and take the opportunity to discover more about the founder of the religious devotion that inspired the building towering above our heads.

Crypts, by their very nature, are almost always sombre and dark areas of penumbra and concealment. Places where rituals take centre stage and cults are slowly born. In the candlelight and with the whiff of incense the crypt at the Sagrada Família is no different from any other. It feels at times like a Byzantine sanctuary demanding silence,

reflection and prayer. If there is movement at all it is search-
ing inward looking for safety. Employing a standard neo-
Gothic model, with mosaics and gleaming metal, sweeping
fan vaults and elaborate bosses, it in no way prepares us for
the revolutionary space above, *but* (and this is worth giving
extra thought to) it is still, in essence, the most accurate
reflection of the original concept that inspired the church.

In 1866, the Barcelona bookseller Josep Maria Bocabella
i Verdaguer, increasingly preoccupied with what the more
conservative wing of the Catholic Church saw as a grow-
ing crisis in society's moral and religious values, founded
the Spiritual Association of Devotees of Saint Joseph.
Eccentric and at times passionately chauvinistic, Bocabella
nevertheless was a typical European example of the gen-
eration that had been rocked by the revolutions of 1848.

Although Spain escaped the immediate fallout, it had
been trapped in the ongoing Carlist civil war for more
than thirty years, where reactionary values were pro-
moted to stop dead in its tracks what was seen as a grow-
ing liberal threat.

It had been only two years earlier, in 1864, we should
remember, that Pope Pius IX's *Syllabus of Errors* had listed
the enemies of faith as modernity, rationalism, liber-
alism, religious tolerance, Freemasonry, socialism and
communism.

Bocabella was completely in tune with the Vatican's
views, although at face value he was a pretty unlikely can-
didate, as a small-scale religious bookseller, to start a vigor-
ous rearguard defence of orthodox ultramontane Catholic
values. Looks can deceive, just as they can also reveal
the truth. Bocabella was recorded for posterity by the

symbolist painter Aleix Clapés, an artist best known for his distinctly mawkish religious images, which appear vaporous and other-worldly, as if diffused through a smoky lens. Clapés depicts Bocabella as a hectoring firebrand, dynamically pushing forward from behind his writing desk out into our space. Featured with the drilling gaze of a messianic visionary, he is about to enter battle, quill at the ready.

In the first instance Bocabella could never have imagined how raw a nerve he had touched and how receptive his audience would be. In 1866 he published the first edition of his magazine *El Propagador de la Devoción a San José*, whose first print run, ambitious at 25,000, sold out almost immediately. Bocabella openly admitted that he was inspired by the tried and tested model of the charismatic Salesian priest Jean-Joseph Huguet, who from his base at Sainte-Foy in Dijon wrote on the celebrated conversions of Manning and Newman and lauded Saint Joseph's status as the great advocate of lost causes (whose growing portfolio nowadays includes his supplementary roles as patron of real estate agents, carpenters and social justice). Most importantly, however, Huguet published the influential *Propagateur de la dévotion a Saint Joseph*, and Bocabella had been an assiduous reader of all of Huguet's texts.

Bocabella also had a good eye for business – selling assorted pamphlets, books, membership certificates and more than half a million medallions, getting a good return on merchandising his mission to celebrate the humble carpenter from Nazareth. The money he collected he allegedly squirrelled away, hidden under the floor tiles of his musty old shop, Herederos de la Viuda Pla, in a

dark backstreet, the Carrer dels Cotoners, on the edges of Barcelona's mysterious and sometimes menacing El Born.

Why, it is worth asking, had the cult of Saint Joseph exploded in the mid-nineteenth century? There is certainly an easily mapped growth in Josephology, from Saint Thomas Aquinas in the thirteenth century via the mystic Saint Teresa of Avila during Spain's Golden Age, right up into the nineteenth century to 'the Little Flower of Jesus', the beguiling Saint Thérèse of Lisieux. The pinnacle of Josephology was reached when the saint was enshrined in official Vatican policy with Pope Pius IX's proclamation of Saint Joseph as Patron of the Universal Church in 1870. There are, of course, also sociological and economic explanations for Saint Joseph's increasing popularity. However, one reason for his growing reputation is possibly more elementary. The status of Christ as Son of God and that of the Virgin Mary as Mother of God are inviolate, whereas the chaste Saint Joseph as a model of humility and sanctity is at least a figure of authority that the average working man might find easier to associate with and even – the Catholic Church hoped – aspire to.

With driving simplicity, Bocabella had caught the mood perfectly, reflecting the anxiety and sense of displacement and isolation that wholescale migration to the industrial city brought in its wake. In issue No. 1 of the *Boletín Mensual*, the immediate precursor to *El Propagador*, published on Christmas Eve 1866, Bocabella described society's predicament as similar to crossing the Sea of Galilee in Simon's leaking boat. Temptation was everywhere. Anarchism was just around the corner.

Barcelona, it was true, like so many industrialised nineteenth-century cities, was a city of enormous contrasts. Yellow fever, cholera and outbreaks of other infectious diseases, coupled with abject poverty, famine, overcrowding, high infant mortality, alcoholism, morphine addiction, domestic violence and prostitution on an epidemic scale encouraged, as a counterweight in the Catholic world, an almost medieval view of the terrible power and judgemental nature of God's wrath, which had to be continually meted out on the city of sin. Popular beliefs that terrorised the populace, such as the *Hombre del Saco*, the child-thief-cum-murderer, or Sacamantecas, a terrifying bogeyman who drank children's blood, were common currency. Poverty, superstition and illiteracy went hand in hand. Where Cerda's restructuring of Barcelona had sought practical solutions in enlightened city planning, improved health care and education, Bocabella offered answers that appealed directly to the anxious harrowed soul.

What could be more effective in trying to rebuild a patriarchal society in crisis than calling on the legitimacy of the patriarch to kickstart a renaissance? Within a few years Bocabella boasted 600,000 members in his Asociación de Devotos de San José, at a time when Barcelona's population, despite a demographic explosion, was just creeping up to 300,000. It was obvious that the devotion had spread way beyond the city and Catalonia, and that *El Propagador* was being read right across Spain.

In the literature on Barcelona's Sagrada Família, it is always Gaudí who takes centre stage, followed by Bocabella as initiator of the project. Less is known about Saint Josep

Manyanet i Vives, who was canonised by Pope John Paul II as recently as 2004.

Born into a large peasant farming family, and having lost his father close to his second birthday, Bocabella was sent away as a five-year-old to be taught by the Piarist Fathers. In the key year of 1864, having slowly worked his way up Catalonia's Catholic hierarchy, Father Manyanet founded the Congregation of the Sons of the Holy Family followed by the Missionary Daughters of the Holy Family of Nazareth. Manyanet's rationale was simple: 'Our centres are called "of the Holy Family" because Jesus, Mary, and Joseph are not only the patrons and protectors, but also the model that they should imitate in virtue and firm love of work, since this was the principal aim of the hidden life of Jesus in the humble House of Nazareth.'

The Catalan priest Josep Blanquet in *El Origen de la Sagrada Família* has provided a fascinating window into the extraordinary synergy that evolved between the trio of Manyanet, Bocabella and Gaudí. Though the former was not there at the beginning, both Manyanet and Bocabella brought complimentary attributes to the table. Where Manyanet was charitable and principled, Bocabella was headstrong, driven and dogmatic.

Our reading of Blanquet's fascinating thesis on Manyanet should be modulated, of course, by the knowledge that he is secretary general of the Congregation of the Sons of the Holy Family. But the real depth and subtlety of his response is that what he catalogues, as matters of fact, are the gifts that each of the trio gave to each other and their respective institutions. The furniture and art works are left to speak for themselves, while at the same time being

deliberately invested by Blanquet with the aura of holy relics. Rosaries, religious images and prayer stools in the nineteenth century are almost never great works of art; they are reflections, however, of spiritual ambitions: token offerings of condolence, poignant memories engraved in stone, or sometimes a grateful recognition of the priest's role in the rituals of baptism, first communion and the administration of extreme unction.

Ill for a great part of his adult life and enduring years of painful suffering, Manyanet found immediate solace in the crafts of sculpting, finely detailed marquetry (Gaudí supplying him with a specialist fret saw), and by indulging in his passion for cabinet-making, not unlike his model and namesake, Joseph, the patriarch of the holy family. This fitted in perfectly with Ruskin and Morris's concepts of the nobility of handiwork, its capacity to counteract the alienating effects of the industrial machine and its ability to bring you into closer proximity with God. Commissioned by Bocabella, Manyanet even fashioned a portable campaign altar for Bishop Caixal, who was the Carlist pretender Carlos VII's vicar general for his troops. Caixal played a significant role at the First Vatican Council, where the dogma of papal infallibility was successfully pushed through. The dogma stated unequivocally that the pontiff was 'saved from the possibility of error' and should be recognised for his 'supreme apostolic authority' when speaking 'ex cathedra, that is when exercising the office of pastor and teacher of all Christians'. Caixal, with the ear of Pius IX, was a useful ally to have stalking the corridors of the Vatican, promoting their cause.

Right from the beginning Manyanet had subscribed to *El Propagador* and very quickly became its spiritual advisor and intimate friend of the Bocabella family, on hand to offer succour when their infant, Maria Dolors, suddenly passed away.

Bocabella's devotion to Saint Joseph, the patriarch, can be understood in purely personal terms, having lost his father, like Manyanet, at the age of two. It only needed a spark to transform affection into outright veneration. Manyanet's personal kindness to the family at the time of their daughter's death and his ambitions for the devotion reaffirmed everything that Bocabella held dear to his heart. Bocabella and Manyanet's spiritual consensus and their attention to Rome created the links necessary to win papal approval for their ever-expanding project.

In November 1871 Bocabella embarked on a pilgrimage to Rome inspired by his growing reverence for Saint Joseph as the perfect role model for the working family man. The celebrations for Pope Pius IX's twenty-fifth anniversary, and Bishop Caixal's encouragement and assiduous lobbying behind the scenes, provided the perfect opportunity for Bocabella to further his cause. Pius IX, despite the kingdom of Italy's annexation of Rome, had become the longest-serving pope, almost two millennia after Saint Peter, who according to tradition had been named the first Bishop of Rome. Travelling from Barcelona with a group of twenty fellow devotees, Bocabella arranged for a rare portrait of the Virgin by the wonderful seventeenth-century baroque Counter Reformation artist Sassoferrato and a large solid silver salver depicting the holy family to be taken as personal gifts to the pope. On their return

journey the devotees visited the Holy House of Loreto, the Christian ur-space where the Virgin Mary had lived. The small building had been miraculously transported by angels, from Nazareth to safety in the Christian West, just before the Crusaders were expelled finally from the Holy Land. After a brief stop-off in Croatia, the Holy House had to flee the threat of the insurgent Ottoman Turks. Today it has found its final resting place in Loreto, in the green heart of the Italian Marche, where, housed in the Basilica della Santa Casa, it is protected for posterity behind an elaborate Renaissance marble screen designed by Bramante. The experience provided Bocabella with a profound lesson in the almost aural and mystical power that a building might possess, as if the bricks, mortar and plaster bearing witness to the sacred might almost speak and slowly release their closely guarded secrets.

Almost immediately on his return, the inspired and newly invigorated Bocabella, following Manyanet's suggestion, decided that the Asociación de Devotos de San José should seek to build a permanent home in the form of an expiatory temple where sin and suffering could be transformed into faith and salvation. His initial idea was to build an exact replica of Loreto, including a faithful copy of the Holy House.

In 1877, the Asociación de Devotos de San José had moved on far enough to appoint the official diocesan architect Francisco de Paula del Villar and request he come up with some plans. By immediately rejecting Bocabella's fantasy of building an *ersatz* Catalan Loreto, del Villar almost certainly sowed the seeds for later discord. The rejection made perfect sense. Why ask an architect for a plan if you already had

the model in your head? Del Villar, a competent but unimaginative architect, resorted instead to the fashionable neo-Gothic style, with a floor plan employing the standard Latin cross, which offered a pedestrian although perfectly satisfactory solution.

By 1881, the Asociación had raised enough money to buy a large 12,800-square-metre plot, for a mere 172,000 pesetas, on the outer edges of the Eixample, which had been set aside as a racetrack for horses. Crossing the municipal boundary into the village of Sant Martí de Provençals, the site was technically outside the city limits. As the Mir painting *La catedral de los pobres* revealed, the area was predominantly scrubland and as contemporary photos confirm, it was littered with shanty huts, garden allotments and herders grazing goats and sheep. Good fortune favoured the Asociación's choice of prioritising the need for maximum space with the possibility of further room for expansion over their initial desire for a more central but more restricted city plot, which anyway finally turned out to be unaffordable. It proved a blessing in disguise. In 1897 Sant Martí de Provençals was absorbed into the city and over the next decades the city's growth moved out across the scrubland in wave after wave of urban development, as gradually the Sagrada Família found itself positioned in the heart of the new metropolis. The city had finally come to the Sagrada Família. Reflecting on the changes, Gaudí later commented: 'Everything about the Sagrada Família is providential: its site lies in the centre of the city of Barcelona, at an equal distance to the sea and to the mountains, to the Sants and Sant Andreu barrios, and to the Besòs and Llobregat rivers.'

The first stone was laid on St Joseph's feast day, 19 March 1882, in a ceremony presided over by Josep Urquinaona, the Bishop of Barcelona, Josep Morgades, the Bishop of Vic, and Luis de Cuenca, president of Juventud Católica, and, of course, attended by Manyanet and Bocabella. In a moving gesture, Bocabella gifted Manyanet the silver chalice used at the inaugural mass, which he had personally received from Pope IX as confirmation of full Vatican support. What is fascinating is to observe the process of patronage, fundraising, the diplomatic pursuit of papal support, the choice of architect and the choice of appropriate style. Furthermore, the subtle development of the programme of iconography had to be refined through continual discussion between the architect-builder and client. The process had remained essentially unchanged since the days of the early Church, two millennia before, and curiously gives us a fascinating window into the workings of the likes of the great Abbot Suger at Saint-Denis in the early twelfth century. The laying of the first stone at the Sagrada Família was therefore a symbolic gesture that didn't just commemorate its beginning, but also the vision, patience, resilience and determination needed throughout all the preparatory groundwork that had gone on before. It had been an act of faith. In that sense, 19 March 1882 marked and celebrated the end of a very long beginning. But a beginning, at least, that had a clear end in sight.

Such large-scale prestige projects were always accompanied by subtle negotiations that recognised the need to attend to the exigencies of both power and propaganda. For the Asociación de Devotos de San José, the privilege of receiving Pius IX's papal imprimatur – normally reserved

as a licence to print a pamphlet or book, as Bocabella the religious publisher knew only too well – came at a cost, with the Vatican receiving fifty per cent of all further donations.

Del Villar immediately set to work. Within months, however, there was growing friction between the architect and the hands-on, opinionated Bocabella, who as the building's promoter clearly led the Asociación's Junta de Obras, the building committee. As arbitrator, the junta could call on the experience and advice of Juan Martorell as a dispassionate observer and final adjudicator. The conflict between diocesan and official city architects and their more brilliant rivals is a constant that by now has been transformed into a trope, with the official architect normally able to set the rules of the game and clip the wings of the upstart. The Asociación de Devotos de San José, however, was and still remains a private body, freed from the larger part of administrative interference. This is an important fact to remember when faced with the unique Sagrada Família, and the inevitable question arises: 'How did the authorities ever allow it to be built?'

Martorell was quick to agree with Bocabella that the pedestrian del Villar was pursuing the wrong course. According to Daniel Giralt-Miracle, one of the great Gaudí authorities, Bocabella disagreed with del Villar's choice of excessive width for the columns in the crypt but also, more importantly, on his insistence on using expensive blocks of Montjuïc stone throughout, rather than the customary infill of cheap rubble core. Was Bocabella beginning to remember del Villar's rejection of his Loreto dream in which the architect had forgotten the maxim

that clearly states 'The customer is always right'? Or was he acting on Martorell's advice, which concluded that the relationship was now beyond repair? Bocabella instantly dismissed del Villar, who briefly played out his distress in the popular press.

What followed has become hopelessly clouded by time-honoured myth. Bocabella, it seems, requested that Martorell now finish the job. Martorell, in turn, and perhaps under pressure from the attentions of the press and Barcelona's architectural fraternity, concluded that it would be wholly inappropriate for a neutral arbitrator to profit from his own supposedly dispassionate advice. Bocabella now had to find a replacement.

What then ensued, as a result of Bocabella's hot-headed reaction, has gone down in Barcelona folklore. In a dream, Bocabella was rescued from his predicament by the vision of a blue-eyed, ginger-haired knight in shining armour carrying not a lance but presumably a compass and protractor, ready to step into the breach. The description, at least the facial details, perfectly fit the appearance of the 31-year-old Antoni Gaudí. The myth element is important. According to Josep Miquel Sobrer in *Catalonia: A Self Portrait*, it immediately legitimised Gaudí's status as if anointed and 'chosen by God'. This myth, if believed, consequently afforded him more autonomy and certainly boosted the building's prestige. The wonderful story, however, hides a more mundane reality.

While not famous, Gaudí was becoming more widely known. He had worked with Martorell in Comillas. In fact, he had also worked briefly as an assistant to del Villar at the holy shrine of Montserrat. Was Gaudí the perfect

compromise, someone taken on, as Giralt-Miracle suggests, initially just to put the project back on track following del Villar's original plans; an olive branch that suited both parties? Or, was he, as it turned out, the perfect replacement? As a young novice architect, Gaudí hardly posed a threat to the established del Villar, whose pedigree placed him at the heart of the previous generation. Equally, Martorell would be there to look over his shoulder and edit any youthful extravagance. Martorell may well have orchestrated the introduction of Bocabella to his flame-haired protégé while the young visionary crouched over a drawing desk back in his studio. That is, if an introduction was needed at all. It is highly likely that Bocabella had met Gaudí before, perhaps in Montserrat, at the Ateneo club, the *excursionistas*, or any of the other societies frequented by the Catalan bourgeoisie. Conversely, it is almost impossible to imagine that Gaudí, in the incestuous and gossipy world of Barcelona architecture, would not have known everything about the intrigues at the Sagrada Família.

Gaudí had just won the commission to build a summer residence for the tile manufacturer Manuel Vicens i Montaner, in the village of Gràcia, which would become a glorious peacock display of all his ingenuity and decorative talents. With its *Arabian Nights*-inspired exotic smoking room, its polychrome lookout towers and dramatic belvedere, it was nothing if not original. Glowing marigold tiles placed on the exterior were set off by wrought-iron gates, fashioned from endlessly repeated motifs of dwarf palm leaves; the *Chaemerops humilis* that Goethe had so admired in his hugely influential *Metamorphosis of Plants*, where he set out to unite a

symbolic and scientific reading of nature. Goethe's sem-
inal work, inspired by a love affair with the *Urpflanze* he had
seen in Padua's botanical gardens, sparked off a revolution in
biological science in which ultimate reverence was reserved
for the dominion of that humble leaf – the true Proteus.
Gaudí was the architectural heir of this vision of divine
nature, and like Goethe would in turn celebrate his love
affair with the dwarf palm's spiky green fingers and its
powerful telluric pull. While the German romantics had
been overawed by the dramatic Montserrat, it was Gaudí
who captured their pantheism and placed it at the footstool
of the Catholic faith.

On a less elevated level, the factory at Mataró also
demanded frequent site visits, as did Gaudí's growing
interest in the young schoolteacher Pepeta Moreu, whose
family he visited every Sunday in the town. Pepeta's exotic
past in the city of Oran, one of Algeria's major ports, with
her first husband Joan Palau, an abusive adventurer and
one-time Carlist soldier, set her apart. It transpired that
Palau was also a bigamist, who abandoned her overnight
just a few months into her pregnancy. Even these trials
and tribulations failed to break her indomitable spirit.
Penniless Pepeta had paid for her passage home to Mataró
by playing the piano in a bar. In *El Gran Amor Imposible*,
Agustí Soler narrates Gaudí's frustrated courtship of the
beautiful, socialist-leaning Pepeta, who was not to receive
the annulment of her marriage until April 1889.

In 1883 Gaudí was also asked to build the won-
derful El Capricho in Comillas for Máximo Díaz de
Quijano, a close relation of the eponymous Marquès.
Gaudí's extravagant design was entrusted to his old

friend and classmate Cristóbal Cascante as on-site assistant. In September of the same year, Eusebi Güell acquired the Can Cuyàs de la Riera estate in Barcelona's Pedralbes district and it was clear that Gaudí would receive more work there. In just a few years he had transformed himself from a low-paid architectural assistant and one-man band to a fashionable architect of promise with a studio employing assistants.

Bocabella's invitation to Gaudí to continue the Sagrada Família therefore arrived at a key moment in his life, when the architect himself could legitimately set the agenda and make his choices from a strong position. Was he too backed up with work to accept Bocabella's offer? Was he perhaps, considering his work at the Mataró cooperative, ideologically opposed to the cultural matrix and the singular aura that surrounded and attached itself to an expiatory temple? Or perhaps too proud and impatient to be saddled with another architect's less-than-inspiring model? Bocabella's reputation as a messianic micro-manager might have been built on little more than hot air and malicious gossip, but surely Gaudí would have been briefed upfront by his colleague and mentor Juan Martorell. Having weighed up all the pros and cons, in November 1883, Gaudí accepted Bocabella's invitation.

Overnight, Gaudí was catapulted into the top flight of architects, not just in Catalonia but also in all of Spain. In that year, Gaudí could not have imagined the enormity of his choice, or that the Junta de Obras would remain supportive of the snail's-pace progress of the works that would obsess him until his death forty-three years later.

Gaudí is now recognised almost universally as a genius, although there are critics who cannot accept his

late-nineteenth-century religious *mentalité*, which places so much emphasis on a pessimistic world view so unrelentingly obsessed with suffering and sin. Even early fans like the great poet, his friend and supporter Joan Maragall eventually tired of inhabiting the same mental space, which he found so crushing. Other critics, and Gaudí would have been the first to agree, focused on his hot-headed, sometimes overbearing character. What no one, however, credits Gaudí with is his clever tactical brain.

Inheriting del Villar's rigid plan might have transformed a lesser man from an architect of promise into a mere shadow, broken down by the relentless drudgery of having to religiously follow someone else's ideas. But almost immediately, hobbled by del Villar's neo-Gothic footprint, Gaudí improvised by pushing the column heights up to lend the crypt a nobility previously lacking. Gaudí's first priority was to win the confidence of Bocabella and the Asociación's Junta de Obras. Whether by design or not, Gaudí's speedy completion of the crypt by 1889 won him the admiration and trust of his clients, as well as buying himself time. The crypt, the size of a decent church, could now serve as a parish church and host all the special celebratory masses planned by the Asociación. With their immediate needs served, Gaudí could now rethink the whole design.

Gaudí's next decision almost defies logic. Instead of doing what we witness on a walk past almost any building site, namely building from the foundations up, Gaudí for some reason changed the rules. Normally, most architects would spread their builders out across the entire site so that the structure could be roofed out and secured as

soon as possible from the elements. However, most unusually, Gaudí decided to focus all his energies on just one façade. Even then, having dramatically edited back his focus, Gaudí would only ever see a fraction of the entire building finished within his own lifetime.

Under Gaudí's direction the Sagrada Família would always remain an architectural laboratory as well as a community of minds and Catholic fellowship.

Gaudí's observation, typically mixing up the everyday with the oracular, was that God, as his ultimate client, appeared to be in no hurry. Gaudí's apparently throwaway comment reveals like no other the relativity of the Catholic imagination's relationship to time.

Gaudí was in for the long haul – the journey to eternity.

Over the next thirty years, Gaudí would share his work on the Sagrada Família with his secular projects, including a few select houses for the *gent de bé*, a park, a convent, a bishop's palace, a palace for Güell, a model village and a crypt, and each cross-fertilised and fed the other. Every project threw up new problems and therefore demanded novel solutions, many of which were of startling originality. A common constant was Gaudí's obsessive focus on detail. Yet even when creating something as humdrum and everyday as a new door handle, a gate or a set of hinges, Gaudí's ambition and self-belief was astonishing. All previous styles in architecture had their problems and their weaknesses, just as all attempts at creating perfection were inherently flawed. Gaudí's favourite style was the Gothic. He had inherited it at the Sagrada Família from del Villar in its more contrived second-hand version as the neo-Gothic.

Gaudí upheld the notion that Gothic, although marvellous, was essentially a crippled style. The flying buttresses were like the crutches of an invalid; they were beautiful but unsuccessful attempts at hiding the building's incapacity to soar up unassisted to the heavens. The spectacular drive upwards of earthbound stone was an illusion that Gaudí laboured hard to discover and then gracefully hide.

For the last decade of his life all the projects that had taken his exclusive attention away from the Sagrada Família were either finished or were dropped in favour of what he came to recognise as his magnum opus.

The first place in the Sagrada Família where Gaudí could really make a mark was when the building works finally reached ground level, at what architectural historians call the chevet – the area that contains the apse at the west end of a church, where the altar is traditionally placed and framed perfectly by a surrounding ambulatory. Just off to one side Gaudí placed the Rosary Chapel with a neo-Gothic entrance arch. For the keen eye the capitals that sit on top of the supporting columns are certainly worth a second look.

On the left a Catalan worker, in traditional costume, wearing the telltale *espardenyes*, is tempted with a bag full of corrupting gold. On the right, more dramatically, a screaming devil, distorted like the famous anamorphic skull in Holbein's painting *The Ambassadors*, places a sphere into the hand of a kneeling worker. Examined closely, the sculpture reveals that the sphere's surface is covered with a pattern of blunt nipples which, once filled with the highly sensitive chemical compound mercury fulminate, act as percussion caps on this deadly Orsini bomb. It is as if the carnivalesque, often scurrilous, misericord carvings found hidden under Gothic choir stalls and the surreal world of gargoyles have been blended with contemporary reportage. It is a uniquely strange choice of subject matter for a Christian

temple but it sat at the heart of the expiatory spirit of this growing church.

On September 1893 General Martínez Campos, Catalonia's captain general, miraculously survived an assassination attempt on the Gran Via in Barcelona when the anarchist Paulí Pallàs threw two Orsini bombs at his horse and carriage. Executed a fortnight later with the brutal *garrote vil*, Pallàs's 'martyrdom' inspired a string of copycat bombings in the name of the anarchist cause. The following month, halfway through Rossini's *William Tell* at the Liceu opera house, Santiago Salvador launched two Orsini bombs down from the top tier of 'the gods' into the stalls where Barcelona's fashionable *gent de bé* sat, killing twenty-two and injuring a further thirty-five. Overnight martial law was enforced, followed by brutal repression and censorship of the anarchist press.

The deadly cat-and-mouse battle between the authorities and the anarchists employed the whole catalogue of dirty tricks, from forced confession by torture, the use of agent provocateurs, to indiscriminate acts of terrorism.

For the innocent caught in the middle, like Gaudí's worker portrayed on the Rosary Chapel door, what was needed in Bocabella's opinion was firm Catholic leadership. The abandoned underclass felt differently. They felt sidelined by the stagnant status quo of the political system of *turnismo*, where the two major parties cynically took turns to share out the spoils. At the same time, for many the Catholic Church offered no real solution to their miserable lives but sat at the very heart of the problem. What the disaffected increasingly demanded was a revolutionary grassroots overhaul that turned society on its head. Sick of the

piecemeal measures and the pathetic palliatives that kept the establishment firmly in place, it is not surprising, in hindsight, that a millennial mindset infected the political debate.

In parallel with completing the early foundations of the Sagrada Família, Gaudí had also been working on the Palau Güell, just off Barcelona's notorious Ramblas. Situated at the gateway to the vice-ridden Raval, the notorious Barri Xino (as it was then known, meaning 'Chinatown'), opposite a brothel and the louche Edén Concert, it was a strange choice of site for a bourgeois palace, even if it was designed as a kind of moral lighthouse and example to the lumpen poor. The Güells soon tired of it, despite its astronomical cost.

Of greater importance, in terms of its symbiotic relationship to the Sagrada Família, was the pavilion gate entrance Gaudí designed out at Les Corts, once again for Güell. Here at last Gaudí began to feel his way towards the concept of building as narrative. Gaudí was asked to provide a porter's lodge and stables, small in scale, to flank an entrance gate. Gaudí's ingenuity was put to the test. Employing the humble materials of adobe and plaster befitting a stable block, he added decorative detail by pushing a mould into the wet plaster to create semi-circular patterns and, more unusually, he carefully inserted small shards of coloured broken tile into the wet mortar. Caught in the right light, the building was enlivened by the cast shadows and sparkling detail.

The real drama and architectural showmanship was focused, however, on the elaborate great iron gate

depicting a dragon with its gaping maw reaching out to threaten the visitor.

Working together with Güell, Gaudí had been inspired by his growing friendship with Catalonia's great poet-priest Jacint Verdaguer. It was Verdaguer's epic poem *L'Atlàntida,* published in 1877, which had won him the prestigious title *Mestre en Gai Saber* (Master Troubadour).

In Verdaguer's sweeping cantos, the young Columbus, after being shipwrecked, is inspired by the legend of Hercules to continue voyaging and discover America. The epic *L'Atlàntida* was really a thinly disguised homage to the new Hercules, Eusebi Güell, who had recognised that the new labours were industry and colonial trade as he and his fellow industrialists steered the Catalan economy towards even greater heights. Gaudí focused on a single scene. The dragon Ladón was twisted around Güell's giant gatepost guarding the golden apples in the legendary Garden of the Hesperides. It had become a favourite theme of the European romantic movement during the nineteenth century, particularly for the Pre-Raphaelite painters, who focused on the orange blossoms and those beguiling Nymphs of the West dancing in the golden night. Gaudí's interpretation was equally picturesque, yet completely original, playing off the aesthetic tension created by juxtaposing ancient mythology with the immediate thrill and appeal of a fairground attraction. It was pure Gaudí, using dramatic imagery to entertain and instruct.

What the Güell commission also revealed was Gaudí's growing involvement with the Catholic Church and a highly influential group of churchmen who acted as patrons, friends and mentors. Verdaguer's position as

private chaplain to the Marquès de Comillas provided one important link. In 1887 Gaudí was commissioned to build Bishop Grau's palace in Astorga. Hailing originally from the Baix Camp, Bishop Grau's career had successfully mixed a passion for sacred archaeology with his dynamic ministry. In 1888 Gaudí was further awarded a commission by Father Enric d'Ossó to complete the Teresianas convent in Barcelona, which he transformed into a beautiful essay on the hypnotic power of the repeated use of his leitmotif the catenary arch. The rhythmic progression of the space leading down the brilliant white corridors expressed perfectly the intense spirituality of the mystic Saint Teresa of Avila. It was spare and minimalist; a perfect space for quiet contemplation.

The following year, in 1889, the Marquès de Comillas tempted Gaudí to make one of his rare trips beyond Catalonia's borders to inspect the possibility of building a Franciscan mission in Tangier. The project never got beyond the drawing board, but it did give Gaudí the opportunity to imagine the construction of a wedding-cake cluster of towers with their dramatic silhouette. All these religious commissions would find an echo in the Sagrada Família, acting as laboratories for Gaudí's relentless search for a higher form.

All was to change at the Sagrada Família with the death of Bocabella on 24 April 1892. The position of president of the junta immediately passed to his son-in-law, Manuel de Dalmases i de Riba, who promptly died months later, as in turn did his successor Francisca Bocabella after a few weeks. Gaudí could still call on the moral support and friendship of Father Manyanet, but the workings of

the junta were forced to change. By 1895 the presidency had become institutionalised, with the Bishop of Barcelona inheriting the post. In many ways, bringing the Sagrada Família within the area of responsibility of Barcelona's bishop brought with it a certain sense of security and continuity.

The calm within the cosy circle of contacts, however, was dramatically rocked in 1894 by the shocking news that the Marquès de Comillas had thrown the famous Verdaguer out of his house. Wild rumours circulated of the poet's runaway generosity as almsgiver, his unwelcome advice to the *marquesa* to retire into a convent, and worse still his alleged involvement with exorcism and demonology. Verdaguer railed: 'Lifelong friends and beloved relatives were treacherously sold off for thirty pieces of silver.' Bishop Morgades of Vic took Verdaguer under his control and immediately stripped him of priestly office. Verdaguer, broken down, described his pathetic fall from his eminence as the celebrated *Mestre en Gai Saber*: 'I've become trapped in an iron circle and go round and round without the possibility of escape.' At the height of Catalonia's Catholic revival it was a masterclass in hubris, enforced humility and the wide-ranging powers of the Church.

Possibly out of sympathy for his friend, Gaudí's Lenten fast that year transformed his face into a gaunt and some said 'heavenly' mask, and brought him perilously close to death's door. It is a telling detail that despite the intervention of his father and Dr Santaló, it was only when Bishop Torras i Bages intervened that Gaudí gave up his fast. In Gaudí's journey towards a deeper faith, 1894 is the key year when the growing myth of his asceticism and

association with Saint Francis, the patron saint of the environment, really began to take off.

Despite distractions, Gaudí continued to remain focused on the Sagrada Família. In 1892, Gaudí's team of more than fifty workmen, guided by his expanding studio of assistants, embarked on laying the foundations for the north-facing Nativity façade. It was both a deliberate and tactical choice. Gaudí later observed, 'If, instead of building this decorated, richly ornamented façade, we had started with the hard, bare and skeletal Passion façade, people would have rejected it.' And Gaudí was right. When the much-decorated but distinctly mundane sculptor Josep Maria Subirachs finally took on the Passion façade almost a century later, in 1987, it would prove highly polemical and would receive vicious critical opprobrium reminiscent of the Dominican Father Couturier's earlier savaging of the banality of Catholic kitsch.

It is at this point, standing in front of Gaudí's Nativity façade, that we should stop and stare. It is here that we get to experience the alpha and omega of Gaudí's imagination and its full cosmic range. He would never see it finished, but it remains his most ambitious work.

Above our heads the four honeycomb towers rise skywards in their vertiginous ascent, just as the central triumphal arch, in complete contrast, seems to bear down upon us, creating a curious and uncomfortable sense of dislocation. This is the Burkean sublime playing its dramatic register from awe to terror. As is typical with Gaudí, there are a myriad of architectural precedents informing his design. The Catalan Romanesque tradition of

sculpted portals, often painted with polychrome interiors, immediately springs to mind, as does that highly coloured faith machine the Gothic high altar – the *retablo mayor*. Although traditionally seen as lower down the aesthetic hierarchy, the popular *belens* – nativity scenes – so prevalent in Catalonia, were quoted here on a massive scale. Never far from Gaudí's mind were the mystery plays and the sculptural ensemble of the *pasos* brought to life when paraded through the street during Holy Week. Gaudí also found inspiration in those charming little religious vitrines placed high in their niches in the Barri Gòtic's narrow streets and the roadside shrines decorated with *ex votos*. Also, of course, Gaudí could reference the myriad of popular religious plaster models created for mass consumption, the medals, plaques and pressed-tin images that hung off the back of every door.

Gaudí in characteristic fashion would take these ideas and rethink the whole ensemble employing revolutionary new techniques. He would also, and this must have tested the junta's patience, rethink, rework, pull down and rebuild areas that he felt might be improved. The painstaking attention to detail and the painfully slow progress were surely also reflections of the fact that Gaudí's funding came from subscriptions and donations, which acted as a brake on hiring a huge team of workers to speed up the work.

The initial idea for the Nativity façade was simple and traditional, with three decorated arches representing Hope, Charity and Faith. The broader sweep of subject matter from left to right narrates with astonishing realism the main events surrounding Jesus' birth. There

are a whole host of different images and enticing details to immediately distract the eye, crowded together and stuck to the surface like barnacles on the cliffs by the sea. At first, the effect of baroque extravagance coupled with Gothic *horror vacui* is confusing. But once the eye is focused, it is Gaudí's search for verisimilitude that we notice first.

Legibility is of central importance to Gaudí's concept, as his main ambition was to create a Bible in stone. His insistence on realism was intended, on one level, to be literal, while leaving very little space for the imagination. Gaudí insisted on the primacy of God's creation through his faithful *imitatio Dei* of the Lord's divine handiwork by insisting, whenever possible, on perfect mimesis.

In terms of art history and the development of sculpture, we should remember that it was in 1876 that Rodin's nude lifesize sculpture of the soldier Auguste Neyt, entitled *The Age of Bronze*, had caused a scandal, with critics claiming the sculpture was actually a plaster cast taken directly from life. There were certainly connections between Rodin and Gaudí, with the sculptors Emili Fontbona and Ramon Bonet i Savé working for both. But, more importantly, we should always remember, when looking at the Sagrada Família's Nativity façade, that in the background there is the looming presence of Rodin's *Gates of Hell*.

If some see Gaudí today as traditionalist and conservative, others pick up on his position as a visionary leader of the architectural avant-garde. They are both essentially right. Gaudí was a catalogue of contradictions. Gaudí had no problem with faithful copies of nature using plaster moulds, as we saw with the repeated dwarf palm motif

at the Casa Vicens. But for Gaudí, ornament was never just decorative addition: it had to speak. Furthermore, it needed to be faithful to its geographical location by creating a strong sense of Catalan identity. A powerful feeling of attachment had to be promoted through recognition and familiarity so that the New Testament stories felt more contemporary and real. Ornament, Gaudí hoped, could transport the familiar biblical stories onto home soil so that they might be appropriated as moral examples for Barcelona's lost poor in desperate need of guidance. It was a perfect example of Catholic paternalism. Many of the new urban underclass had poured into the city from the country during the early days of industrialisation. With the arrival of the phylloxera plague in 1879, which destroyed the vineyards in Catalonia, the stream of migrants turned into a flood. Nature, if it was to provide solace, had to be transformed into a residual memory that could be found easily in this nostalgic Eden in stone, where sculpted geese and chickens perpetually pecked at the ground.

There is a good example of Gaudí's concept on the arch furthest to the left. We are offered the touching scene of the Flight to Egypt, carved in stone on a perfect human scale. The Virgin Mary, with her modesty veiled, sits astride a donkey, accompanied by faithful Joseph and babe in arms. What the innocent viewer will not know is that the donkey is not just any donkey. Gaudí had sent his team out into the nearby streets to scout out an appropriate model – not too well fed – to pass off the illusion of a beast of burden that had travelled more than a hundred miles through the desert. Finally, the right donkey was spotted as a rag-and-bone man

foraged the neighbourhood looking for scrap. What ensued is extraordinary. Gaudí had written in a teenage book the observation: 'It is mad to try to represent a fictional object.' With the advantage of maturity he later reflected: 'I believe like Da Vinci that decadence sets in as soon as man forgets to look at nature.' Gaudí looked at the donkey and decided to let it appear as itself. Hoisting it up in a harness, he proceeded to attempt to cast it in its live entirety in plaster. When it kicked in resistance, it was briefly chloroformed to finish the job and then released and returned. The resulting sculpture lies somewhere between the realms of taxidermy and life-modelling. The same technique was used for the chickens and geese, which were quickly greased up and sedated before being immortalised in stone.

Like a theatrical impresario or the director of a play, Gaudí sought out the appropriate character to create the perfect *mise en scène*. Gutiérrez, an overweight goatherd who may inadvertently have infected Gaudí with brucellosis by supplying spoilt milk, was the model for the Roman prefect Pontius Pilate. Josep, a sad alcoholic who soon died of delirium tremens, fitted the look of the deceitful and guilt-stricken Judas. Standing at a bar in the Barrio of Sant Martí, a six-toed giant, a perfect diabolical freak of nature, was persuaded he would make a perfect model. Cast in the role of Roman centurion, the slaughtered baby innocents lay twisted at his feet as a desperate mother struggles to stay his malevolent arm. The horrible illusion is made doubly shocking by the knowledge that these little innocents were based on actual casts of stillborn children provided by a medical friend of Gaudí's; the resulting images are

as poignant as a death mask yet somehow more affecting and real.

An experiment that went too far could easily have ended in tragedy. Ricard Opisso, one of Gaudí's assistants, was persuaded to stand for a full-life cast and fainted. Opisso, however, held no grudge; in fact, it was he who persuaded the anarchists in 1936 in the first explosive days of the Spanish Civil War not to desecrate Gaudí's tomb. Gaudí may have appeared eccentric, with an empirical love for experimentation that appeared to know no bounds, but all his assistants remained fiercely loyal and followed him to the end. Many of them stood to be immortalised as biblical figures stalking the stage across the Nativity façade. These were the main characters, Gaudí's team of workers, the industrious extended Catholic family, just as it had been 600 years earlier at Santa María del Mar.

What was obvious was that the same techniques of mimesis could be applied to background detail and flora as well. The barley-twist columns flanking the central arch sprout into palms, which in turn support giant snails that are crowned by trumpeting angels. In the space under the arch, usually reserved for archivolts, Gaudí turned cosmic with stone transformed into molten lava, while the signs of the zodiac struggled to escape the fertile chaos and find their final symbolic form. It is immediately reminiscent of the *non finito* sculptures of Michelangelo but on a much grander scale.

Arriving at the Nativity façade unprepared, it looks at first appearance like a wild pictorial forest struggling to find a meaningful *gestalt*; halfway between Ovid's *Metamorphosis* and the promised Second Coming. A building that seems

trapped in a state of flux, both becoming real and yet also melting slowly away.

In a parody of the biblical commandments, Dalí would later write in his personal list of 'the five principal perfidies' that 'those who have not touched the bony structures and the living flesh of his delirious ornamentation are traitors'. 'Traitors' is, of course, a perfect example of Dalí's overblown rhetoric playing to the gallery but, as always, he is wonderfully perceptive. Gaudí's architecture invariably walked a delicate line between seduction, pleasing the crowd and religious devotion. That is exactly why he is so popular today.

Heading up Gaudí's team of sculptors was Llorenç Matamala, who had joined him on day one. 'Come and work with me at the temple, Señor Llorenç, and you will have work for life.' It was Matamala's task to transform and scale up Gaudí's fantasies, which were often tested out first on a more manageable miniature scale. Flowers and vegetation were almost as mechanical as producing the *millefleurs* background on a medieval tapestry. Details such as shellfish, sea anemones and the sea urchins that had transfixed Gaudí in his youth were also relatively simple. Dividing the central arch were two columns that rested their weight, and that of the precipitous overhang, on the backs of a tortoise and a turtle, one from land and one from the sea, representing universal harmony and longevity and in oriental mythology are often depicted as supporting the world. Gazing up from the central position right to the top, a magnificent cypress tree crowned the central spire. Gaudí insisted on finding exactly the right tree, although he would never see it in place.

If Gaudí's obsession was to create the illusion of reality, all was not quite what it seemed. Brought up on a diet of magnificent *retablos mayores* – those overwhelming gold-embossed surfaces that act as faith machines – Gaudí was already thinking about the problems of scale. Some *retablos* like Pedro Dancart's sixteenth-century masterpiece at Seville cathedral, which took eighty years to complete, were as tall as five-storey houses. Within their gigantic structures there was often room for offices and changing rooms for the cathedral canons. What the medieval carvers working on these *retablos* observed was that the size of the figures had to increase the higher up you went if the viewer stood a chance of recognising the scene. Gaudí's technique of casting directly from life could only really work at eye level and just above. Scaling up the size was relatively easy to calculate depending on the height the object was to be placed. Gaudí, however, developed an entirely new technique that he had already hinted at in the anamorphic devil that had tempted the worker on the Rosary Chapel door. For a figure up high to be read as correct, it didn't just need to be scaled up, it also had to be distorted and elongated. What was required was a foolproof compensatory method of correcting the sculpture that took into account the perspective of the viewer below.

Before the birth of CAD programs, the calculations needed for such a task were complicated or at best hit and miss. Working with his team, Gaudí devised a system of using photography to calculate the correct distortion required. First an object was either cast or copied faithfully. With the sculptures of the human figure the failure of the Opisso experiment had already ruled out casting directly from life. The finished life-size plaster of a saint or an angel was therefore first recorded in a photograph. The photograph was then placed leaning back at the angle that corresponded to the height that the sculpture would be placed on the façade and then carefully re-photographed head on. The resulting image revealed the level of distortion required to make the final sculpture appear in perfect proportion. The legs needed to be longer, the head stretched, the midriff pulled out as if elastic, so that the viewer below would see the image in the correct proportions. It was a method that was fraught with problems, with the original model passing through many visual filters, from life to plaster, from photograph onto deliberately distorted photograph and finally back again to its new plastic reality. Hopefully, the scale of the image would also relate perfectly to the entire decorative ensemble of

the façade. That was the idea. It was painstaking, costly and laborious. Particularly when you realise that this is really just the beginning of the process. Matamala and his team, working directly from the photograph, would set about creating what they hoped was a 'perfectly' distorted sculpture in plaster. The image was hoisted up, twenty or thirty metres into the final position, to await assessment by Gaudí. If deemed acceptable, it was carefully lowered down and faithfully copied in stone, to be raised once more and finally put in place.

Gaudí's interest in the human figure was never just skin deep. Like the Philadelphian painter Thomas Eakins, who studied anatomy for years, Gaudí needed to understand what made the body stand up. For Gaudí the human figure represented God's finest handiwork and could teach even an average architect an important lesson on structure and how to build. Obtaining a skeleton, Gaudí rewired the joints so that the skeleton could be positioned into various poses with appropriate gestures. Walls of mirrors were placed in a hexagonal format with a life model or the articulated skeleton placed in the middle, allowing the viewer to see around the figure from multiple viewpoints. A studio assistant might stand in as the suffering Christ hanging on the Cross, twisted in pain, and be observed carefully in the round. For Gaudí, attention to detail, although perhaps never noticed by the viewer, was an integral part of his honesty and his devotion to God. Perhaps, as was the practice with the seventeenth-century sculptures of the recumbent Christ by Gregorio Fernández, Gaudí also meditated on these images of suffering as a kind of psychological aid in coming closer to God.

All of these different techniques and specialities demanded that the Gaudí architectural practice at the Sagrada Família be divided into various zones.

In the grounds Mossèn Gil Parés, the parish priest, had built a house. On the floor above the priest's rooms there were photographic studios, a large drawing studio, Gaudí's hideaway office, which was filled floor to ceiling with models, drawings and a daybed, as well as a large room for maquettes and models, some on a scale of one to ten. In a separate area there were sculpture studios and stores for building equipment.

Gaudí was always working on two entirely different scales, ranging from the microscopic to the cosmic and from apparently insignificant details to the full projection of his gigantic church. Details on the Nativity façade demanded a special focus, particularly the complex iconography. Models of the façade gave the team direction even if at first sight it appeared chaotic to the untrained eye. However, although Gaudí was focusing almost exclusively on the Nativity façade, it was only a small part of the whole. In tandem, Gaudí was also drawing up plans for the entire Sagrada Família and creating detailed models that would be used in the future to complete the project. Work progressed at a steady pace. Construction had started on the Nativity façade in 1892; two years later the façade of the apse was finished and by 1899 the Rosary portal on the Nativity façade, with its depiction of the Orsini bomb, was also finished. It is not certain when it first dawned on Gaudí that he would never see the Sagrada Família completed, but in preparation for that eventuality he wanted to leave an accurate model for his successors to use as a guide.

By 1902, almost twenty years after inheriting the building project, Gaudí had finally finished his first wonderfully evocative depiction of how he wanted the Sagrada Família to look. Over the next twenty-four years it would go through many revisions and rethinks but essentially always remain the same. The smudged black-and-white charcoal drawing appeared to evoke sandcastles in the sky, rising up like a mysterious silhouette. The *sfumato* dreamscape fitted in perfectly with the symbolist aesthetic of its day.

If Gaudí's exacting, often obsessive methodology was one obvious reason for the slow progress on the Sagrada Família, there were always further distractions.

While Gaudí worked on the Sagrada Família other work kept coming in. In 1900 he won his first and only gold medal – for the Casa Calvet, a neo-baroque townhouse that sat over the Calvets' textile shop in Barcelona's Eixample. Relatively sedate in comparison with Gaudí's later work, the Casa Calvet's exterior was decorated with cornucopias, swags of flowers and the mushrooms the late Sr Calvet had loved to pick. Today, in keeping with the gastronomic theme, the textile shop houses an excellent restaurant serving refined Catalan cuisine.

In 1898, the same year as he drew up plans for the Casa Calvet, Gaudí started work on Eusebi Güell's utopian project for a textile factory, school and workers' housing at the Colonia Güell, twenty kilometres west of Barcelona on the banks of the river Llobregat at Santa Coloma de Cervelló. Most of the project was passed over to his assistant Francesc Berenguer, but Gaudí reserved the workers' church for himself.

At the Sagrada Família he had inherited Francisco de Paula del Villar's crypt as a foundation on which to build. At the Colonia Güell he could start afresh on virgin soil. Gaudí's design for the church, which was again left unfinished, gives us a unique window into what the Sagrada Família might have been had Gaudí won the commission before del Villar had planned the axis, settled the footprint and suggested the early neo-Gothic style.

The only part existing is Gaudí's crypt, but it is an absolute masterpiece and his greatest work. Again, as with so many other projects, it fed back ideas into how the Sagrada Família was going to proceed. As a crypt it defies all expectations. Gaudí's crypt is light, heavenly, a brilliant symphonic poem of meandering brick that teases the eye, rhymes, sings and breaks all the rules. In terms of architecture, it is Gaudí's passport into the pantheon of the very select few. An hour spent in the Cripta Güell – with its stained-glass butterfly windows opened to the hot pine-scented wind – is utterly magical.

Out in the woods Gaudí's team set up a research shed in which over the next ten years they perfected a highly elaborate catenary model with a system of hanging strings. Each string as it looped down had attached to it a little bag filled with shotgun pellets that represented an exact weight corresponding to the carefully calculated stress. Gaudí's model, almost four metres tall, was in effect an analogue computer that acknowledged his acquaintance with Arab astrolabes perfected more than a thousand years earlier in Moorish Spain. Used as a method for calculating the correct inclination of columns to compensate for gravitational thrust, it proved a wonderful aid. It has to be seen to

be believed, and most definitely also seen to be understood. For Gaudí, however, it had a far deeper resonance. Based on the theory of gravity, it suggested that in reality it had been designed in partnership with the Creator himself. It was a fascinating conceit. When the model was finally completed, it was photographed, the image flipped over and the arches could now rise skyward.

As his researches in Santa Coloma pressed on and the Sagrada Família needed constant attention, Güell added to the load by requesting he plan an entire estate, the Park Güell on the outskirts of Barcelona. From Palma de Mallorca, Bishop Campins required Gaudí's advice on completely rethinking the Gothic cathedral, dismantling the choir to create a diaphanous space, and further design ideas. By 1904 Gaudí was already overseeing five major projects when Sr Batlló called on him to totally refurbish his townhouse on the Passeig de Gràcia.

The Casa Batlló's shimmering façade is another of Gaudí's triumphs. Working in tandem with his most gifted assistant, Josep Maria Jujol, he transformed a drab dwelling into a multicoloured riot of tiles, skull-shaped balconies and a roof silhouette representing a dragon, with the tiles doubling as the monster's scales. Pierced through by a Christian cross, it alluded to Saint George – Catalonia's patron saint – and the dragon. It was a delightfully entertaining example of nationalist propaganda.

In the interior of the house's spacious *piano nobile* there is hardly a straight line to be found, as plaster, wood and tiles sweep the eyes through the rooms, passing a womb-shaped inglenook on into the salon, where a giant seems to have pulled the ceiling round into a spinning vortex.

Despite the decor, the Casa Batlló is a wonderfully prac-
tical dwelling built for a family keen to display their dar-
ing modernity. It still looks revolutionary more than a
century later.

The Batlló house led on immediately to the much
larger commission for the Casa Milà, three blocks up the
Passeig de Gràcia. Known as La Pedrera – the quarry –
Gaudí's corner development built for the dandy Mila and
his wealthy wife Rosa has justifiably been declared a World
Heritage Site. Over three years, 1906–9, La Pedrera
slowly found its final shape, hidden from public gaze
by a hoarding. When uncovered, it immediately sealed
Gaudí's reputation as the most outlandish, innovative,
riotous revolutionary working in the Iberian Peninsula,
if not the world. The cartoonists had a field day with its
cave-like appearance, transforming this grotto deluxe
into a home for reptiles and snakes or alternatively por-
traying it as a landing bay for Zeppelin airships or with
the caped Richard Wagner looking up at the craggy edi-
fice smouldering enviously in full *Götterdämmerung* mode.
The wrought-iron balconies fashioned and beaten into
shape by Jujol looked like seaweed washed up on the side
of a cliff.

Just as Gaudí's use of broken tiles in the *trencadís* tech-
nique had foreshadowed the invention of cubism, so too
Jujol's daring assemblage of welded steel prefigured the
sculptures of Picasso, Anthony Caro and David Smith.

Once again Gaudí's brilliant imagination had triumphed
at the cost of being completely misunderstood. Behind the
façade, or rather integral to it, was the concept of a spiritual
pilgrimage up through its seven floors and its diaphanous

attic and out onto the roof, where, accompanied by chimneys appearing as mutilated ghouls, the pilgrim could look out across the city of sin. La Pedrera was a giant rosary in stone that still carefully hides its mysteries from all but the most attentive eye.

The brilliance of La Pedrera put Gaudí in the dubious position of becoming the most fashionable, sought-after architect of the day. If he had chosen to capitalise on his fame, Gaudí might have built dozens of other buildings for Barcelona's bourgeois elite illustrating his fascinating ongoing dialogue with natural forms. Fortunately for the Sagrada Família, La Pedrera was Gaudí's last secular work. Pere Milà had finally lost patience. Battling the town hall on a daily basis to exempt La Pedrera from the strict ordinances set out for the development of the Eixample, and the ensuing fines, effectively drained all the remaining goodwill; Gaudí walked off site, vowing never to return. The rooftop sculpture of the Madonna flanked by angels was never put in place. There are many architectural critics who see that as a very good outcome. For Gaudí, however, La Pedrera without its rooftop Madonna had lost all its meaning and poignancy, and, most importantly, had been robbed of its redemptive power.

From Casa Milà it was a short walk to the Sagrada Família, and from the late summer of 1909 to his untimely death in 1926 Gaudí concentrated exclusively on his expiatory temple. There, at least, his refined religious temperament, now built on daily readings of the Bible and Dom Guéranger's *L'année liturgique*, and fortified by daily confession, could focus exclusively on what he now saw as his magnum opus.

In 1905, Gaudí's domestic life on the surface appeared more comfortable as he moved into the show house designed by his assistant Berenguer in the exclusive Park Güell. Living with his aged father Francesc meant, however, the joint task of caring for his dead sister's daughter Rosita Egea, who as a chronic alcoholic sedated herself on a cocktail of bad wine and cough medicine. Their shared calvary transformed Gaudí into a committed enemy of all psychoactive substances, including coffee, tea, alcohol and tobacco. The idea that the *Amanita muscaria* – magic mushroom – domes on the Park Güell porter's lodge are a coded admission of Gaudí's hidden love for hallucinogens is laughable. Look carefully and you see that the telltale white spots that denote the deadly fungus fly agaric are upturned coffee cups.

Sadly, Gaudí's father died within a year of moving into the Park Güell, at the age of ninety-three. It was now just Gaudí and Rosita living in their retreat, visited daily by nuns to clean and keep Rosita company, while the architect descended into the city to spend the day thinking through his elaborate plans for the Sagrada Família, as the model-makers laboured to create a 3D projection from which they could all proceed.

A visit to the Gaudí House Museum reveals the architect's increasingly ascetic lifestyle. His bedroom is really a priest's cell. The family diet and health regime inspired by Dr Kneipp, a founder of the naturopathic medicine movement, focused on fresh air, hydrotherapy and a sprinkling of salad and nuts. The only wine to pass Gaudí's lips was when attending mass.

Gaudí's paternalism, refined through his early coopera-
tive experiments at Mataró and the Catholic workers'
retreat at Güell's textile plant at Santa Coloma, would find
their final expression at the community he was building at
the Sagrada Família. Workers were strongly discouraged
from taking their lunchtime break in the surrounding bars.
Allotments were parcelled out for them to practise their
husbandry skills and grow vegetables and tomatoes to take
home to the family. Workers who had reached retirement
age were, whenever possible, kept on in less strenuous
roles, going round with water, running errands and any-
thing else they could comfortably manage. In an age when
the welfare state was a distant idyll, this must have pro-
vided support to many families.

Slowly the Sagrada Família was beginning to integrate
itself into the everyday life of Barcelona. En route to its
acceptance there were barriers to overcome. In 1903
Barcelona town hall had invited the young French urban
planner Léon Jaussely to rethink Cerdà's plan for the
Eixample, which they felt had become outdated. Gaudí
lobbied Jaussely to revise the street pattern around the
Sagrada Família, carving away at the corners of surround-
ing blocks to create a star pattern that would heighten
the impact of the temple's imagined silhouette. Gaudí's
suggestions were both costly and perhaps too innovative,
and didn't make it to Jaussely's final plan, submitted in
1907. In the same year Cardinal Casañas, Barcelona's
bishop, proposed that the crypt might be officially desig-
nated as a parish church under his jurisdiction. The move
was diplomatically stalled, leaving the Sagrada Família
with full autonomy.

Over the years Gaudí had received support in the press from the poet Joan Maragall, another *Mestre en Gai Saber*, who had hailed the Sagrada Família as integral to the identity of the growing metropolis. Not always entirely in tune with Gaudí's philosophy, Maragall nevertheless called for people to donate and involve themselves in building this glorious church.

On site, work progressed, as always . . . at snail's pace. In 1909, in keeping with the holistic concept of creating a Catholic community, a parish school was planned for the south-east corner of the central plot. Sunscreens were to be placed out in the playground where the pupils could learn to nurture and shade their individual plant pots, handed out to promote a sense of responsibility and develop a caring attitude to the natural world. The main building, a fantastically simple but elegant solution to the demands of working to a tight budget, was later described by Le Corbusier as one of the greatest buildings of the twentieth century. In its scale and humility, it is everything that the Sagrada Família is not. Devoid of ornament, the drama lies in the undulating roof that sweeps over the space in elegant waves of tile. It has been imitated since, most notably by Santiago Calatrava at the Ysios wine bodega in Laguardia in the Rioja and again in Dallas, Texas, with his mobile sculpture placed over a pool outside the Meadows Museum, the wonderful 'Prado in the Prairie'. In fact, the legendary school building often overlooked by the visitor has been rebuilt twice, having suffered on two separate occasions from vandalism and fire. Like so many other spaces created by Gaudí – the attics in the Casa Batlló and the neighbouring La Pedrera, for instance, or the corridor in

the convent of the Teresianas – the genius is found in their spare, stark and economical beauty.

Gaudí's genuine sympathy with his workers and his ambition to create a community were best illustrated by his support for the Sagrada Família school.

If the Nativity façade appeared threatening, the school seemed immediately more approachable and human. It is probably the single reason that the Sagrada Família religious complex, by association, escaped the worst ravages of the riots that were soon to sweep through the city.

Since the Orsini explosives had been launched into the stalls of the Liceu back in 1893, Barcelona had been sitting on a ticking time bomb. Abject poverty and all the associated social ills had never gone away, providing the perfect conditions for increased anarchist activity. In June 1896 the Rubicon was crossed with the bombing in Barcelona of the Corpus Christi procession. The government's response was quick and brutal, as five anarchists were rounded up and immediately executed. The cycle of repression rapidly escalated as more than 400 suspected anarchist sympathisers and Republicans were jailed and tortured in the castle of Montjuïc. In response, on 8 August 1897, the Italian anarchist Michele Angiolillo travelled to the resort spa of Santa Águeda, in Mondragón in northern Spain, and assassinated the prime minister Cánovas del Castillo. The Spanish–American War in 1898 further exacerbated the problems of the poor as the streets filled with the returning wounded. The first years of the new century in Barcelona witnessed a dramatic increase in industrial unrest followed by further repressive clampdowns. The Bill of Jurisdictions in 1906 legitimised the introduction of martial law under

specific conditions. To add to this volatile cocktail, conscripts were called up in Barcelona ready for immediate deployment to Morocco.

In the middle of July 1909, troops were being shipped out to Morocco on a daily basis, with the soldiers marched through the city down a corridor of wailing 'widows' straight to the docks. A further call-up of 40,000 conscripts was Madrid's response to the colonialist 'Scramble for Africa' that was spiralling out of control. Rif bandits threatened Spanish harbour facilities in Melilla and Tangier, and more importantly the mines of Beni-bu-Ifrur, which were run by a consortium that included Count Romanones, Güell and the Marquès de Comillas. On 24 July, *El Poble Català* – on the eve of the anniversary of the infamous 1835 riots, which during the Carlist civil war had desecrated the monastery of Poblet, Gaudí's childhood obsession – announced prophetically that: 'The valves have been closed and steam is accumulating. Who knows if it will explode.'

Following reports of early defeats in Morocco and atrocious conditions there, wild rumours circulated.

On Monday 26 July, Barcelona woke up to a general strike. The muddled response from the authorities, with Barcelona's Governor Ossorio refusing to impose martial law, fanned the smouldering flames. Captain General Santiago quickly stepped in. It was too late. Within hours, civil disobedience was transformed into violent outbursts of anti-clerical rioting. On Monday night the Marists' Workers' Circle of Sant Josep was burnt down. The working-class neighbourhoods of Barcelona were transformed overnight into battle zones, with makeshift

barricades designed to prevent cavalry charges thrown up across the narrow streets in scenes reminiscent of the revolutions of 1848 and the French Revolution. From the heights of the Park Güell, Gaudí could see smoke plumes rising over the city below.

On Tuesday, in the Barranco del Lobo in the Gurugú Mountains overlooking the coastal plain of Melilla, General Pintos was ambushed by the Rif and lost close to 200 conscripts.

Barcelona rapidly descended into total anarchy as Church property became a target for an orgy of revenge. By the end of the week, when the authorities once again took control, more than forty religious establishments and twelve churches had been recorded as burnt out, while graves were desecrated and nuns' corpses paraded down the street in a diabolical version of the city of Berga's La Patum festival. Despite the violent scenes, only three priests were killed.

Gaudí's response ran the full gamut of horror and disgust to residual sympathy for the average working man. He had once famously admonished Father Brasó for his lack of leadership at the moment the *pueblo* needed help. This was precisely the reason why the Sagrada Família was being built. And it is perhaps a testament to Gaudí that despite a strike committee meeting held at the Sagrada Família at the height of the rioting, it was left untouched. The memory, however, of the *Semana Trágica* remained an integral part of the psyche of Barcelona's divided world.

For Gaudí, however, the *Semana Trágica* had an immediate impact. It was in response to the revolutionary carnage that Pere Milà refused Gaudí's demand to cap

La Pedrera with a four-metre-tall Madonna placed up on high as if guarding the streets. Gaudí walked away even more convinced that only the Sagrada Família might end the madness and eventually save the day.

On 15 November, Bishop Laguarda officially inaugurated the Sagrada Família school. The next three years for Gaudí, however, would prove the most difficult of his life. The emotional fallout of the *Semana Trágica* and Milà's refusal to bend to his wishes gradually took its toll. In May 1910 an attack of brucellosis, mood swings and bouts of high fever forced Gaudí to leave Barcelona for recuperation in Vic. The following summer, after a relapse, Gaudí was accompanied by Dr Santaló up into the Pyrenees to Puigcerdà where, increasingly debilitated, he requested a lawyer to witness his will. Then, in January 1912, Rosita, who had been cared for by the nuns, finally passed away.

Brought up on the philosophy of suffering as a necessary prerequisite for future salvation, Gaudí soldiered on. In Vic he had plenty of opportunity to discuss with his friend Bishop Torras i Bages the purifying powers of pain. Having recently delivered his pastoral *La Glòria del Martiri*, Torras i Bages understood Gaudí only too well. Beauty and harmony, they both agreed, always came at a cost. It was death, after all, that gave meaning to life. Over the next few years his spiritual soulmates Francesc Berenguer, Bishop Campins, Bishop Torras i Bages and Eusebi Güell died, leaving Gaudí feeling increasingly isolated. Focused exclusively on the Sagrada Família, and with no one to share his lonely evenings, Gaudí's appearance notably changed as he increasingly resembled a hermit, slightly dishevelled,

his legs bandaged against the cold, the vanity of youth forever gone.

In many senses these were also his most glorious years, the suffering proving strangely cathartic as he carefully refined his ideas. Rarely consulted, the Sagrada Família archives hold a full set of the *Albums* published by the Asociación Espiritual de Devotos de San José, which constitute an invaluable document for the study of the master's work.

In the final chapter I discuss the continuation of the Sagrada Família after Gaudí's death. It is interesting that those architects who followed in his path have often been criticised for not following his original designs. It is obvious that the critics have never studied the *Albums*.

The first *Album*, published in 1915, is full of fascinating detail. For the first mass celebrated back in 1885 the conch shells ready to hold the Holy Water were catalogued as a gift of the Philippines as a tribute to the imperial ambitions of the Catalan church. Across the Nativity façade shell motifs could be found everywhere. Even the towers – which reminded many Catalans of the *castellers*, the human towers built during the *festas* – were almost certainly inspired by the ubiquitous molluscs, the shells of Aquarius, washed up on every beach. By 1915 the *Album* was already celebrating the façade's decorative range. It promised to offer the viewer the 'animals and flowers of Christmas and the Nile'. The giant cypress tree, which symbolised death and resurrection, was celebrated for its 'incorruptibility' in whose 'trunk is veiled . . . the Sacred Heart of Jesus'. Gaudí, who must have read the *Album*,

was praised for creating a building that was 'a mystic poem worked in stone', which reflected 'the *alma* of the whole of Spain'.

By 1915, Gaudí had already set the height limit for the building at 160 metres, just short of nearby Montjuïc, a courtesy gesture acknowledging God the Creator's precedence. As of 30 December 1914, the junta had spent 'the huge sum of 3,200,000 pesetas' on the building works. The *Album* proclaimed, 'Our century's egotism had been defeated by Charity and Faith and by devotion to the Holy Family,' while stressing once again Bocabella's core value that 'Providence wants to be built with alms only'.

The 1917 *Album* went into more detail, focusing on the Sagrada Família's historical importance. With comparative drawings its scale was compared to St Peter's in Rome, Santa Maria Maggiore and St Mark's in Venice, the last of which it completely dwarfed. In the back pages of the *Album* the Sagrada Família's footprint was transposed over the Spanish cathedrals of Avila, Segovia, Huesca and Pamplona. It actually approximated in its layout most closely to the pure *tour de France*-inspired Gothic of Burgos and León. The closest in size, however, was the gigantic Seville cathedral, whose founding fathers, the cathedral chapter, had declared back in 1401: 'Let us build a church so beautiful and so grand that those who see it finished will think we are mad.' There was no more fitting tribute to the Sagrada Família than this august comparison.

Put head to head with Salamanca and Toledo, the Sagrada Família still held its own, while next to the imperial scale of Granada there was little to set it apart.

Importantly, the Sagrada Família was considerably larger than Barcelona's own cathedral. Compared to the religious architecture of other countries, it stood up well against Chartres, Rheims, Paris and Cologne. What the *Album* revealed is it what every architectural historian already knows: great architects are immensely competitive.

One detail that even today awaits a diplomatic solution was the inclusion of Gaudí's detailed drawing of two chapels on the far side of the Carrer Mallorca, which were linked to the main body of the temple by a gigantic flying staircase spanning the street. Designated the Baptistery and Forge, these two chapels speak of Gaudí's belief in the purifying powers of fire and water. Today, where the two chapels would be placed stands a block of flats that will need to be razed to the ground if Gaudí's dream is to be finally realised.

By 1922, with the publication of the third *Album*, the money spent on the project had crept up to 3.5 million pesetas. Despite the fact that Gaudí was celebrating his seventieth birthday, he was still described as 'remarkable and young'; he was certainly remarkable but no longer young. In the September of 1924 he was still feisty enough, however, to stand his ground against the police after celebrating a mass commemorating the Catalan martyrs of 1714. Refusing to speak to them in anything but Catalan, he was marched off to the cells. 'The whole thing affected me like a miniature Hell: skinny guards with the sort of appearance that people call that of a "poor devil", the chiefs, better paid, with massive bellies, are the Lucifers who give the orders.'

By the early 1920s, with the rise of the new *Noucentisme* style, Gaudí's architecture was beginning to fall out of favour. It is reasonable to assume that donors were beginning to feel charity fatigue, while the junta might be excused a certain lack of patience as the Sagrada Família seemed to progress as slowly as ever. Gaudí was even recorded as walking the streets begging for alms. Whether true or not, it portrays his dogged persistence and his ongoing belief that patience might triumph at the end of the day.

With Gaudí's father Francesc living to the ripe old age of ninety-three, it was reasonable to assume that Gaudí himself might still have many years ahead of him. Regardless of his own expectations, Gaudí had prepared an exhaustive archive of floor plans, drawings, elevations and detailed models to give direction to any future collaborators inheriting the job. Part of the reason for focusing almost exclusively on the Nativity façade had been to set a benchmark of quality and detail for his successors to follow.

Gaudí over the years had become increasingly interested in music, not surprising for someone fascinated by the transcendent harmony of the spheres. He had always found Wagner's concept of the *Gesamtkunstwerk* – the total work of art – intriguing. The cypress tree would be illuminated by the presence of brilliant white birds. Running up the towers, giant letters sang out their Hosannas. The towers themselves were designed so that the window apertures might murmur with the winds and the specially designed tubular bells would call the faithful to prayer. In January 1925 the first of the four towers, dedicated to Saint Barnabas, was finally completed. *'Fa goig!'* – Give joy! – Gaudí frequently

exclaimed, hoping that his work might give pleasure while also instructing the curious mind.

'*Fa goig*' were also the last words he spoke to his workmen as he set off on 7 June 1926 for confession at Saint Felipe Neri. Minutes later he was run over by a tram. Amongst all the confusion Mossèn Gil Parés and his assistant Sugranyes finally located him in the early hours of the morning, broken and semi-conscious in the public ward of the Hospital de la Santa Creu. Three days later, at 5 p.m. on 10 June 1926, Antoni Gaudí finally died. Joan Matamala was charged with making the death mask, a moving tribute to a genius in repose.

Two days later on 12 June, Gaudí was given the nearest thing to a state funeral that Catalonia had ever seen. Having received papal dispensation, Gaudí was laid to rest in the chapel of Our Lady of Mount Carmel in the crypt of the Sagrada Família, whose construction he had directed forty-two years earlier. It was a poignant closing of a circle, an alpha and omega moment, both a beginning and an end.

Gaudí's untimely death might well have sounded the death knell for the costly Sagrada Família. It was a project that appeared as if it might never end. Its guiding spirit and inspiration, its driving force and unflagging source of energy and optimism, even during the darkest of days, was no longer there to light the way. After the eulogies to Gaudí had been read and his genius proclaimed, reality and the cold facts had to be faced. Over the years the Sagrada Família had occasionally run into financial difficulties. Again and again the project was saved at the last minute by donations that kept the deliveries of materials coming in and the builders on site. Who can now judge whether these acts of charity had been in part a reward for Gaudí's dogged perseverance and the recognition of his genius, rather than a passionate devotion to the Sagrada Família per se?

It would be wrong not to remember and acknowledge the uncomfortable fact that Gaudí and the *Modernista* style were rapidly falling out of fashion. Decorative detailing and obsession with overfussy ornament was distinctly *passé* and depressingly reminiscent of the dark days of the nineteenth century. Nevertheless, there were still some who were prepared to swim against the tide and the seductive allure of fashion, and celebrate the unique qualities of Gaudí's vision and style. The multitudes who had attended

Gaudí's funeral offered a genuine outpouring of their emotions in tribute to his extraordinary contribution and his central position in the formation of a Catalan cultural identity which celebrated the sacred trinity of craft, creativity and Catholicism. The danger of recognising Gaudí, however, as the true apotheosis of Catalan genius, was that without him nothing could ever be the same. With Gaudí gone, who was there to pick up the mantle?

It is perhaps all too easy to play the game of 'What if?' The long autumn of 1926, following Gaudí's death, offered ample time for reflection. Not just time to measure Gaudí's legacy and his originality but also to see whether the Sagrada Família could continue without his peculiar charisma, driving dedication and the loyalty of his team. Gaudí's death offered a legitimate chance to take stock and totally rethink a build that had been swallowing up funds while moving forward at a painfully slow pace. It would not be the first time that a governing board like the Asociación's Junta de Obras would use a fortuitous moment to totally change direction or even pull the plug. Was this perhaps a great opportunity for the bishopric of Barcelona to capitalise on the confusion and impose their wishes on this private body? Were the Devotion and the Sagrada Família still in tune with the larger picture of Vatican policy, or had the catastrophe of the Great War dramatically changed its priorities? Finally, might the Vatican now get involved with the Sagrada Família in a more proactive way?

These were issues that needed thinking through, but there were also more pressing and practical considerations to take into account. First and foremost, had Gaudí left

enough of a footprint and enough documentation, plans and models to guide a successor who might be willing to continue the works? Gaudí had always found solutions to problems thrown up by the architectural process in a creative and reactive way regarding the materials, mechanics, statics, engineering and every other aspect of the design process. As a man manager he had gained the respect, loyalty and affection of his team. The profundity of his religious and spiritual investigations were quite extraordinary, given he was a full-time architect as opposed to a practising priest or theologian. It goes without saying that these were qualities that were next to impossible to replicate amongst Catalonia's architectural fraternity. His aesthetic sensibility was unique, with a magical and uncanny capacity for blending the everyday and apparently ugly, while still managing to wed it to the standard canons of beauty in order to create something entirely new. This was Gaudí's special gift, shared only with Josep Maria Jujol, who after collaborating with him on the Park Güell had gone out on his own and was working predominantly down in Tarragona. If Jujol and the architect-theorist Joan Rubió i Bellver were both now running their own studios and could not be tempted back, who was there with the ability to step into Gaudí's shoes?

Up until his death in February 1914, Francesc Berenguer, Gaudí's *braç dret* – right arm – had been his principal head of studio when the architect's absence for reasons of health or work on the cathedral in Palma de Mallorca called him away. Berenguer's death was a tragic loss but Gaudí's studio was full of other talented architects. The least known but arguably the most important assistant to work under

Gaudí was Domènec Sugrañes i Gras. Photos of him late in life with his impressive walrus moustache and hangdog face suggest a serious and solid *burgès*, a scion of the Catalan bourgeoisie. Sugrañes and Gaudí's relationship went back a long way. Sugrañes passed one of the most important qualifications in coming from Reus, the city of Gaudí's birth – and from the same social artisan trading class – where his parents ran the sweet shop El Globo (sweets being one of Gaudí's very few indulgences). Allegedly Gaudí had seen promise in the young Domènec's skills as a draughtsman when he spotted him sketching in the sweet-shop. Twenty-six years younger than Gaudí, Sugrañes followed in the elder architect's footsteps to Barcelona University in 1894, and two years later, aged only eight-een, was taken under Gaudí's, wing; in his guiding role as mentor, Gaudí offered the teenage Domènec his first work experience. Of all Gaudí's team, Sugrañes was perhaps the closest to his own profile of the ideal architect.

Gaudí, however strong-headed and argumentative, had an uncanny gift for getting the best out of his collab-orators and giving them creative space. Sugrañes was no exception, and amongst his private commissions he was responsible for emblematic buildings such as the spectacu-lar Monumental bullring of 1915, a twist on the Gaudínian neo-Mudéjar style (still awaiting redevelopment today, as the offer by the Emir of Qatar in 2014 to transform it into Europe's largest mosque finally fell through). Like Berenguer, Sugrañes was taken on by Gaudí years before officially qualifying as an architect. Gaudí had a healthy dis-dain for the official academic route into the architectural profession and no doubt felt, and not without reason, that

his workshop was a more worthwhile experience than any dusty drawing hall or endless hours spent with an uninspiring teacher.

Sugrañes would come to work with Gaudí on the Torre Bellesguard – where he played his variation on the *trencadís* Gaudí house style – and on the masterpieces Casa Batlló, Park Güell, Colonia Güell and La Pedrera. Perhaps Gaudí saw in Domènec Sugrañes the man he might have become had his romantic life taken a different turn. Sugrañes, unlike Gaudí, married. His wife was the unusually liberated Xaviera de Franc, who had studied art at the Acadèmia Borrell. Over the years the growing mutual respect and trust between the two men meant that Sugrañes would step into the vacuum left by Berenguer and become Gaudí's *braç dret* and eventually one of the executors of his estate. Over the years they grew so close that Sugrañes, on his day off, accompanied by his son Ramon, would join Gaudí on his Sunday stroll along the promenade to listen to the master's musings on the Mediterranean's classical past and the peculiar quality of its light, which he felt was perfect for a real understanding of volume.

Sugrañes was the obvious choice for the junta if they wanted to continue with the works. His intimate knowledge of Gaudí's plans for the Sagrada Família suggested a smooth transition, but there were also reasons to be cautious. Sugrañes, with Gaudí's blessing, had also taken on private work. In 1924, close to Reus, his project for the country villa Mas del Llevat signalled a distinct move towards the more classical *Noucentisme* style that was becoming increasingly fashionable. *Sgraffito*-carved plaster motifs framed an entrance that suggested an interior of

classical calm: harmonic, symmetrical and a return to the straight line. In the coastal resort of Salou, in 1924, the elegant Casa Loperena followed a similar idiom, succeeded in 1925 by the more radical Casa Solimar, a revolutionary apartment block whose austerity seemed to look to north European precedents from Berlage to the Bauhaus. Did Sugrañes have the requisite humility to submit to Gaudí's plans and to a style that might be rapidly going out of date?

Was, indeed, Sugrañes up to the challenge that the Sagrada Família posed? Gaudí had frequently insisted that God's divine presence was encrypted into the complex patterns and arcane geometry of nature. In many ways Gaudí's response to nature was a cross between that of the great eighteenth-century amateur 'parson-naturalist' the Reverend Gilbert White, and a sophisticated scientist seeking out the secrets to creation. Was Sugrañes, left to his own devices, capable of breaking and reading that code?

Right at the beginning of his career, back in 1878, Gaudí wrote a revealing essay on religious architecture entitled *La construcción del templo*. Despite the unique trajectory of his career, which passed through neo-Gothic, Victorian eclecticism, neo-Mudéjar, *Modernisme* and then on towards a unique and revolutionary new personal style, his observations back in 1878 still ring true. 'The church,' he stated, 'should inspire a sense of Divinity, with all its infinite qualities and attributes.'

With no interviews or conversations between Gaudí and Sugrañes on record we can only assume that master and assistant went through everything in exacting detail. What we do know, however, from *Album 4*, published in 1929, was that the Sagrada Família plans and models had been

continually reworked and refined. The innocent viewer
looking at Gaudí's work for the first time, used to the
generic cube-like quality of most other buildings, should
be forgiven for seeing the surreal surface and assuming that
Gaudí was the master of caprice and permanent impro-
visation. Nothing could be further from the truth.

*Album 4*, like all the previous editions, compared the
Sagrada Família to other cathedrals – in this instance, the
early classic Gothic St Elizabeth's church in Marburg built
by the Order of the Teutonic Knights, as well as Our Lady
of Strasbourg, the tallest building of the entire Middle
Ages, which Goethe described as the 'sublimely tower-
ing, wide-spreading tree of God'. There could be no bet-
ter description of the effect Gaudí hoped to achieve at the
Sagrada Família.

Further illustrations of the capitals for the elegant
triforium which bathed the nave in light displayed once
again Gaudí's capacity for creating an entirely new design,
one that blended Visigothic simplicity with an eccentric
barley twist.

The forest of columns that marched up the nave like
poplars lining a French road, and those circumnavigat-
ing the altar, were dedicated to the various Catholic sees
across mainland Spain; some have cited the eucalyptus
tree as inspiration for this lapidary forest. On enter-
ing the Gloria façade the first two columns encountered
were Santiago de Compostela and Toledo, respectively
Europe's greatest pilgrimage site and the primate cath-
edral of Spain. Nodding to both, the design of the Sagrada
Família also set out Gaudí's intention to rival the two and
give Catalonia a new spiritual centre like a contemporary

Montserrat. Passing on through, the next columns were dedicated to Valencia, Zaragoza, Granada, Burgos, Seville and Valladolid, amongst others. On the transept the columns were given over to Vic, Solsona, Tortosa and La Seu d'Urgell, while around the holy of holies the four that framed the altar were dedicated to Barcelona, Gerona, Tarragona and Lleida. Nothing had been left to chance. Catalonia, of course, in the hierarchy of Spanish churches, was right at the top.

Sugrañes was the perfect disciple, changing nothing, respecting Gaudí's master plan to the letter. Limited as always by precarious funding, Sugrañes continued to work on the three remaining towers and the Christmas tree that crowned the Nativity façade.

For Sugrañes and the junta, the problems facing the continuation of works on the Sagrada Família would quickly be overshadowed. From 1923 to 1930 the dictatorship of Primo de Rivera was welcomed by the Catalan ruling classes, who felt increasingly threatened by unionism and anarchism and welcomed Rivera's 'strong' response. However, Primo de Rivera immediately disbanded the Mancomunitat Catalan government and attempted to eradicate the Catalan language, persecuting traditional Catalan organisations and other separatist manifestations. Primo de Rivera's call for an '*España una, grande y indivisible*' meant that it was politic for the Sagrada Família to play down its well-known Catalanist associations. Primo de Rivera was as tough on the Catalan Church as he was on the trade unions with regard to their loyalty to the Spanish state. Intransigent priests who insisted on celebrating mass in Catalan were dismissed and even the Bishop of

Barcelona, Josep Miralles, was finally moved sideways and sent into exile in Palma de Mallorca. The seemingly harmless *sardana* dance that sits at the heart of Catalan cultural identity was banned, alongside the more inflammatory Catalan anthem *Els Segadors*. Primo de Rivera introduced tough press censorship, banning most Catalan newspapers, and offered insidious encouragement to informers prepared to denounce those who failed to toe the line. By 1930, Primo de Rivera's persecution of Catalanism had managed to negate all his earlier support from Catalonia's institutions and ruling elite.

In architecture it was also easy to step over the line of what the dictatorship permitted. Puig i Cadafalch, one of Gaudí's most gifted rivals, as president of the Mancomunitat had gone into exile in France when the government had been dissolved in 1924. In 1929, now rehabilitated, Puig i Cadafalch played a central role in organising the International Exposition, but then antagonised the dictatorship when the four freestanding gigantic classical columns placed at the foot of Montjuïc were torn down because of their perceived association with the bands of the Catalan flag.

Sugrañes would have to tread carefully. The dictatorship can hardly have forgotten Gaudí's flagrant refusal in 1924 to obey the new law that forbade the celebration of Catalonia's national day, the *Diada*, on 11 September. Attempting to attend the special mass at the basilica of Sants Justo y Pastor, Gaudí had refused to back away or speak to the police in anything but Catalan. Jailed overnight, at the age of seventy-three, the incident became an instant cause célèbre.

In 1928, a hugely important development for the future of the Sagrada Família was finally put in place with the designation of an undeveloped square opposite the planned Passion façade, crossing the Carrer de Sardenya, as a city park named the Plaça de la Sagrada Família. It wasn't quite the result that Gaudí had hoped for in 1916 when he submitted to the city planners his idea of cutting four long triangular *xamfres* – chamfers – off the surrounding blocks to offer a more dramatic view of his temple. Nevertheless, it ensured that at least one façade could boast an undisturbed view for passers-by to step back and stare in wonder at its dramatic silhouette.

In 1929, way ahead of its time and indeed in one of those classic cases of putting the cart before the horse, Sugrañes also worked on plans, which have since been lost, for an electric lighting system to floodlight the dramatic façade. Gaudí, as Sugrañes well knew, was open to all the latest innovations as long as they made sense.

By 1930 Sugrañes had completed the three remaining towers of the Nativity façade, whose corkscrew spiral staircases had the ability to give intrepid explorers vertigo and claustrophobia at the very same time. With their fish-scale fenestration of slanted openings the four towers were some of the tallest and most arresting structures in Barcelona. Back in the 1860s it might have been the urban planner Ildefons Cerdà whose model for the Eixample gave Barcelona its distinct trademark grid pattern, but it was Gaudí, with these towers, who would transform the Sagrada Família into the city's enduring symbol and seductive logo. Three years later, in 1933, Sugrañes completed the giant cypress tree that furnished the Nativity façade

with a coherent silhouette. The cypress's soft evergreen needles formed a backdrop to the polka-dot effect of cavorting white ceramic doves as the eye was led skywards to a red cross crowned by the Holy Spirit with wings outspread. Below, on the right-hand side, the Portal of Faith was still being finished with the help of Joan Matamala, whose father and grandfather made up a sculptural dynasty devoted to turning Gaudí's dream into concrete reality. The Sagrada Família's continuation had always depended on the cross-generational loyalty of families like the Matamalas and, most importantly, the Bonet and Bassegoda architectural dynasties.

The Portal of Faith, devoted to the Virgin Mary, has a striking naturalism that transforms the visionary and biblical into the everyday. The scenes depicted full scale are the Virgin's visitation to Elizabeth, the adolescent Jesus preaching in the temple, the presentation in the temple with Simeon uttering his moving *Nunc dimittis*, crowned finally by a representation of the Immaculate Conception. Stealing the show, however, is a homely scene of Joseph and Mary in the carpenter's workshop with the teenage Jesus, arm raised as if caught in slow motion, ready to bring down hard his woodcarver's mallet on a chisel. It is an arresting idealised portrait of the holy family spearheaded by its patriarch Joseph, who represented the perfect model for the working man: humble, obedient, industrious and proud of his craft. The irony, of course, is that his son Jesus would become the revolutionary Messiah.

As Sugrañes was struggling to finish the Portal of Faith, the working man in Barcelona was being offered other

routes to paradise, starting with improving his conditions while still on earth. Or, to put it another way, it was becoming politically imperative for those in a position of power to alleviate the hellish conditions that defined the miserable existence of a large percentage of the working population.

By January 1930, Primo de Rivera's lacklustre dictatorship had run out of steam and military support. The initial reforms, which had succeeded in modernising Spain's infrastructure, were eventually frustrated by Primo de Rivera's inability to put limits on the reactionary power of the army and the Church, as well as his unwillingness to promote agrarian reforms that might upset the landed elite. His success in breaking the *turnismo* of the major parties, who had taken it in turn to rule Spain over the previous half-century would, however, leave space for more radical parties to fill the vacuum and operate on the main political stage. Having lost the support of the army and King Alfonso XIII, Primo de Rivera resigned, to die in exile in Paris a few weeks later.

Alfonso XIII was next. On 12 April 1931, the Republican parties swept to a landslide victory and two days later the king fled abroad. For Republican sympathisers the election victory heralded a period that has been immortalised as the Silver Age. This flowering of the arts is most closely associated with the poetry of Vicente Aleixandre, Pedro Salinas and Jorge Guillén, amongst others, but particularly the voice of Federico Garcia Lorca and his travelling theatre troupe, La Barraca. For the Catholic Church the Second Republic represented a terrifying threat. Cardinal Segura, Spain's primate,

forcefully ordered his flock to vote against the 'anti-clerical' government, which had placed restrictions on Church property, prohibited the religious orders from remaining involved in education, declared processions and public rituals anathema and banned the Jesuits, whom the great philosopher-poet Miguel de Unamuno described as the 'degenerate sons' of Saint Ignatius Loyola.

On 11 May 1931 arson attacks on churches, convents and religious schools in Madrid, Murcia, Malaga and Seville, which were terrifyingly reminiscent of 1835 and the *Semana Trágica* of 1909, polarised Spain and effectively killed off the voice of moderate Catholicism. In Barcelona, specifically, where 'anti-clerical' violence had a long pedigree, the Catholic Church, far from holding a monopoly on morals, was seen by the proletariat as at best ineffective and at worst both insidious and evil. The structure of the Church invaded every aspect of life. Alleged abuses of the confessional and charity only given in return for religious observance were two of the most common grievances that encouraged visceral hatred of the Church. There was little succour to be gained from an institution that preferred to see the workers' miserable lot as somehow deserved and one to be suffered in silence. Or an institution that put its desire for power above its responsibility for delivering pastoral care. The paternalistic nineteenth-century vision of a congregation of working people modelled on the idealised Christian holy family found little resonance in a society that was about to explode.

It was against this backdrop that Sugrañes continued to build. While Gaudí and Sugrañes had undoubtedly dealt

sympathetically with their builders on site, dealing with sickness and retirement with great tact, the religious community was nevertheless built with the expiatory spirit and the doctrine of original sin right at its core. The Sagrada Família school, under the constitution of 1931, would soon effectively become illegal. On 3 June 1933, Pope Pius XI in his encyclical *Dilectissima Nobis* struck back at the Republic's attack on the Church, demanding all Catholics, using all available legal means, fight against those who had committed sins against his Divine Majesty and whose base greed had led them to expropriate its property, its vestments and sacred images. Pope Pius XI claimed: 'Universally known is the fact that the Catholic Church is never bound to one form of government more than to another, provided the Divine rights of God and of Christian consciences are safe.' For most Spaniards, and particularly those who listened to Cardinal Segura, this was blatantly untrue. The Church's reactionary rhetoric was to be countered with revolutionary zeal. What the Church denounced as a growing 'red terror' had to be fought tooth and nail. In this explosive atmosphere, where Church and state seemed irreconcilable, even continuing to build the Sagrada Família could be read as a deliberate provocation and insult to the ideals and aspirations of the revolutionary Silver Age. Everywhere the poison of mistrust spread like a malignant virus, feeding those who predicted a collapse into civil unrest.

Sugrañes, although involved in politics before the First World War, was first and foremost an architect. The completion of the Nativity façade demanded almost no originality or interpretative skills on his part. The next stage,

however, required him to reacquaint himself in depth with the models, plans and drawings that Gaudí had left behind. While Gaudí's guiding leitmotif had been the grace and simplicity of the catenary arch, in practice the Sagrada Família was fantastically complex. Gaudí had struggled hard to arrive at what he imagined was a perfect synthesis of science, the decorative arts and architecture interwoven with Catholic liturgy, the history of the Catalan Church and the mystical geometry of the heavenly spheres; each part, like a building block, underpinning the other. Sugrañes had, of course, been Gaudí's loyal assistant for almost fifteen years and had, like Rubió i Bellver, pondered over the master's aphorisms, off-the-cuff comments, objections and half-processed theories, to establish a guiding rationale.

In 1917, Sugrañes published an essay in the magazine *Iberia* entitled '*Disposición estática del templo de la Sagrada Família*'. (Note that anything published by Gaudí's assistants within his lifetime can be assumed to come with his blessing.) In the essay Sugrañes returned to the essential concept that Gaudí had developed, namely, that his 'new' architectural style was an improvement on the crippled Gothic style, which was supported by the crutches of the flying buttress. Before trumpeting Gaudí's unique qualities, it's worth stressing that the Sagrada Família is far more conservative than often claimed. There are good reasons for Gaudí's conservatism. He was limited initially, as we have already seen, by the neo-Gothic footprint left by del Villar. Furthermore, his clients, the junta, and their target audience, the growing members of the Devotion, were often deeply conservative, if not sometimes reactionary. The neo-Gothic style was safe and comfortable,

both solid and sedate and unlikely to scare anyone with an innate mistrust of the avant-garde.

Left to his own devices and given total freedom, Gaudí might have tried any temple format, from the vast spread of a circular dome to the gigantic single span of an industrial-scale nave, and every other variety of design in between. His sources of inspiration could easily have come from as far afield as the Mayan temples, the Buddhist stupa, Angkor Wat, Hagia Sophia or the Pantheon in Rome, whose photos he had so avidly studied while still at architectural school. But Gaudí made a deliberate decision to stay with the tried-and-trusted Gothic model of naves, aisles and transepts, whose symmetry and balance led the viewer in a direct procession from the great door straight up to the main altar. His first elevations, dating from 1898, were very much a halfway house between Gothic and his *Modernista* style. The four aisles running alongside the towering nave – with its vertiginous, typically Gaudínian catenary arch – were only a third of its height, and each was roofed out with a classic pointed Gothic arch. The novelty was not so much structural as in the detailing and the ornament.

It was not until 1915, having had the benefit of working on the elaborate model for the Cripta Güell and its church out in Santa Coloma de Cervelló, that Gaudí developed the radically new solution that we see today. The aisles in the Sagrada Família would now rise to two-thirds of the height of the nave and all would be roofed out with catenary arches. The aisle columns that join onto the central nave are slightly inclined but branch out half-way up like trees, to create one large diaphanous space, as

intriguing as it is overwhelming. The branches cleverly distribute the load down through the columns, avoiding the need for the massive external buttressing that had in traditional Gothic churches often cast deep shadows onto the windows throughout much of the day. Using a system of placing columns directly on top of other columns, which then divided at the swollen branch collar – a perfect imitation of nature by the ever-observant Gaudí – the relationship of width and height of the nave could change dramatically in comparison to previous buildings. At the top of the clusters of columns, the series of vaults spread out like the leaves on a tree. What Gaudí had discovered was a structural technique for creating an open soaring citadel where the 'heavenly' Mediterranean light might become the major protagonist as the heavy Gothic structure of the Middle Ages was finally modernised and transformed into a luminous shell.

Sugrañes was embarking on the next stage of the Sagrada Família at just the wrong moment. Under the leadership of Prime Minister Manuel Azaña there was no sympathy for a Catholic Church perceived as having strangled Spain's development by promoting a feudal, anti-liberal mindset. In the November 1933 elections, as the left-wing coalition disintegrated, the right-wing CEDA party – the Confederación Española de Derechas Autónomas – led by José María Gil-Robles, who modelled himself on Mussolini, won the elections but without an overall majority. President Alcalá-Zamora, in a deliberate attempt to rein in Gil-Robles's totalitarian tendencies, asked the radical populist Alejandro Lerroux to form a government. What Alcalá-Zamora had not allowed for was

Lerroux's cynicism and CEDA's patience. The following year, on 1 October 1934, Lerroux rewarded CEDA with three cabinet seats. The left-wing response was immediate, as anarchists and socialists called for a general strike.

On 4 October 1934, the Asturian miners' strike rapidly evolved into an insurrection as towns and the provincial capital of Oviedo fell under their control. Following church burnings and the murder of more than thirty priests and businessmen, the government called for army intervention. Brutally suppressed by the young General Francisco Franco, the Asturian strike would leave a death toll of more than 3,000 miners, with ten times that number imprisoned and many more forced out of their jobs.

Despite the Lerroux government's right-wing stance, it was extremely difficult for Sugrañes and the Junta of the Sagrada Família to negotiate their way through this minefield of shifting sympathies. Asturias had awakened them to the hatred and horror that the red terror had unleashed. If Spain was now hopelessly splintered, what hope could there be for an 'expiatory temple'; an institution whose driving philosophy was seen as an integral part of the crisis that it had somehow hoped to solve.

For the moment, the two black years of Lerroux's government, the infamous *bienio negro*, stalled many of the radical religious reforms that had been implemented by Azaña and given the Church some breathing space. However, with the collapse of the Lerroux-CEDA pact in January 1936, the left-wing coalition of the Popular Front won the elections and once again the Church felt threatened. The situation was exacerbated by the replacement of the relatively moderate Alcalá-Zamora, who had resigned

once before on principle over the implementation of the Republic's anti-Catholic programme by Manuel Azaña. Azaña, who had famously said that all the convents of Madrid were not worth one Republican life, alienated the moderates – those tragic figures caught in the middle who, with the benefit of hindsight, have been described as the Third Spain. With Azaña now occupying the post of president, many on the right gave up on parliamentary politics altogether and prepared themselves for a more serious conflict which they were convinced would have to be won by force of arms. On the left, the proletariat were consistently dehumanised by the Church and their protectors, the rural and urban elites and the army. The right-wing propaganda machine transformed left-wing sympathisers into 'the beast' responsible for the blood-thirsty red terror, who acted as lackeys of Moscow. 'Red' now became a catch-all epithet to describe anyone who didn't agree with all the establishment's ideas and dared to think differently or question the status quo that had fed off and brutalised the poor.

What the Church believed was that there was a highly organised conspiracy working to destroy it. During the spring of 1936, hundreds of separate attacks, including the firebombing of churches and political murders, under-standably fed the paranoia across Spain. On the right, fuelled by the anarchist violence, the military conspiracy planning a coup was now in its final stages.

On 18 July 1936 the Nationalist military coup began. Within hours, using Spanish Morocco as a launch-pad, Seville was the first major city on mainland Spain to fall to the insurgency, led there by the inflammatory

sadist Queipo de Llano. News of the brutal repression of Republican sympathisers was broadcast in boastful reports by Queipo de Llano to sow the seed of terror in all those who dared stand in his way. The cult of violence was an essential aspect of the 'crusading' insurgents, who had a colonialist disregard for mercy and human life. Their troops were given free rein to cleanse Spain of what they described as bestial sub-human communist filth. Almost all the other major cities in Spain remained loyal to the Republic.

Under the leadership of José Giral, who was named Prime Minister of the Republic on 19 July, the loyal cities were ordered to arm civilian militia, which resulted in Barcelona falling almost immediately into the hands of the anarchists.

On the same day, 19 July, the CNT – Confederación Nacional del Trabajo – a confederation of anarcho-syndicalist labour unions in tandem with the FAI – Federación Anarquista Ibérica – spearheaded the defence of Barcelona and, after intense battles, isolated the rebels in the barracks of Drassanes and Sant Andreu. Alongside the POUM – the Partido Obrero de Unificación Marxista – the other unions and thousands of workers manning the barricades the CNT–FAI forces quickly rendered the rebels impotent. By 20 July the Catalan Generalitat President Lluís Companys recognised that the CNT–FAI had been instrumental in saving the Republic. Hard on the heels of the defence came the inevitable reprisals that turned rapidly into savage carnivalesque celebrations reminiscent of Brueghel's *Triumph of Death* or Goya's terrifying *Desastres de la guerra*. The world had been turned

upside down and once and for all the workers wanted to cleanse the city of the social and religious structures that had suffocated them and kept them repressed. Fear had been transformed into a euphoric triumphalism that led to scenes of humiliation of the vanquished elite and wild demonstrations of the workers' newly won power. Public spaces, like the squares, the Ramblas and, of course, Barcelona's churches, had to be spiritually and physically, and often violently, adapted to suit new needs.

In a highly symbolic act, the grand Hotel Ritz in all its splendour was requisitioned by the CNT and the UGT and transformed into the workers' canteen Hotel Gastronómico No. 1. From behind the safety of the barricades, deliberately left in place, it was now the turn of the revolutionary committees to create their brave new world.

Many of the stories about the appalling terror that swept the streets have now been accepted as Franco propaganda, but there was without a doubt a brutal settling of scores and a catalogue of ferocious violence. Historians continue to debate the levels of war crimes, intimidation and murders on the respective sides. It is generally accepted that Franco's rebels murdered more than twice the number of the Republicans. Furthermore, the Nationalist terror was official policy, whereas the Republican atrocities were often, however bloody, spontaneous revolutionary outbursts not sanctioned by a centralised political leadership that had lost control and was trying to steer a path away from a hopeless descent into total anarchy. What is certainly true is that the murder of thousands of priests and lay workers was a propaganda disaster for the Republic and jeopardised international

support. Rumours ran rife, as they had done during the *Semana Trágica*, that the priests were far more active than just spouting anti-Republican inflammatory rhetoric from the pulpit. Inevitable fear of the mythical well-trained fifth column – the enemy within – ever-ready to crush the Republic, led to suspicions that the religious communities were storing arms. Any religious community or building was now a legitimate target.

Anti-clerical violence, as Maria Angharad Thomas argues in *The Faith and the Fury*, while unarguably destructive, was seen by many of its perpetrators as a deliberate political act to provide the building blocks for a new society purged of the poison of the past. Nuns, who were often regarded as victims, were therefore seen as being offered freedom from oppression by the burning down of their convents. Priests, recognised as part of the apparatus of oppression, became legitimate targets. Tragically, even those whose lives had been dedicated to selflessly serving the poor were sucked into the terrifying tornado of terror and punished for the sin of association. Only very few communities were brave enough to risk provoking the wrath of the mob to save the lives of their priests.

On 20 July, a group of FAI vigilantes attacked the Sagrada Família. It had been miraculously spared back in 1909 during the *Semana Trágica*, but this time it was not so lucky. Within hours, more than fifty years of work went up in smoke as Gaudí's drawings, correspondence and photographic archive were put to the flames. Thousands of man hours dedicated to complex calculations, as Gaudí patiently developed his modular structure for the Sagrada Família, perished in minutes. From the photos

of Gaudí's studio that are still extant we can reconstruct the look but not the content of the hundreds of rolls of architectural plans. In the sculpture and model studios the anarchists ran amok, smashing everything they could find including the elaborate models and the fragile plaster 3D details which Gaudí preferred above all else. The pungent smell of acrid smoke, the leaping flames and the sound of splintering wood followed by mini-explosions as sculptures smashed to the floor must have been overwhelming. Who knows what was lost from the closely annotated books and catalogues, or, for that matter, the clues to understanding the sources for the symbols and the painstakingly planned iconography? One of the few things saved were the plans for the Sagrada Família school's building by Gaudí's assistant Francesc Quintana, who bravely sneaked in unseen after nightfall to gather what he could, in imminent danger of losing his life.

Just as damaging was the destruction of the stone yard, where the rough blocks were prepared. In the sculpture and carpentry workshops and the studio for the model-makers, all the expensive machinery was vandalised and the buildings set on fire. Two family homes, the porter's lodge and the house of an assistant to the crypt were razed to the ground. The labourers' dressing rooms were torched and the finials around the apse, not yet in place, were thrown down into the crypt and smashed. Looting and the theft of valuables, as recorded across Barcelona's other religious sites, was very low on the agenda. What was important was to 'purify' the space and kill off any possibility of continuity while suffocating the vital memory of any sacred presence. All that Gaudí's work meant to

the iconoclasts was its assumed association with religious repression, which had now been crushed underfoot. While in Barcelona working as a volunteer for the Red Cross, the poet Sylvia Townsend Warner observed that churches had been 'cleaned out exactly as sick-rooms are cleaned out after a pestilence. Everything that could preserve the contagion has been destroyed.'

In the Devotion's newssheet, the *Hoja Informativa*, they described the whirlwind of wanton destruction as creating a scene even worse than a bombing. Having destroyed and burnt as much as possible, the anarchists moved down into the crypt to desecrate the tombs. What the anarchists wanted and what they achieved was to strip away and annihilate every vestige of the sacred. The stone lid to Gaudí's tomb was broken, but they quickly moved on to the family shrine of the Bocabella family, where they proceeded to disinter the corpses and in a ghoulish parade march them out onto the street to macabre shouts of how they had found some rich 'marquesas' for a final waltz.

Scenes like this were repeated all across the city as value systems were turned upside down and a lust for revenge, obscenity and the breaking of age-old taboos created new rituals of humiliation. As in the public hangings on Tyburn's Gala Day in London, the *auto-da-fé* in Toledo or at the foot of the public guillotine during Paris's Reign of Terror, death became a spectator sport. On the Passeig de Sant Joan, one of Barcelona's wealthiest streets where the *gent de bé* normally promenaded of an afternoon, 40,000 people walked past the imposing Salesas Convent, built by Joan Martorell, to stare at the grotesque

spectacle of a row of disinterred nuns, propped up, decomposing, leaning against the wall.

The orgy of destruction that swept Barcelona was a perfect example of the Catalan character trait of *rauxa* – an explosion of crazy, impulsive, hot-headed behaviour – fuelled on this occasion by a mixture of fear and delirious exaltation. The atmosphere was as volatile and incendiary as a can of petrol poured on a fire. Gossip and rumours surrounding the events spread far and wide.

Already in his preface, 'Gaudí's vision', to the work of Clovis Prévost and Robert Descharnes, *La visión artística y religiosa de Gaudí*, Salvador Dalí had celebrated Gaudí. In his usual bombastic style Dalí declaimed: 'the last great genius of architecture was Gaudí, whose name in Catalan means "orgasm" just as Dalí means "desire" . . . I explained that orgasm and desire are the distinctive figures of Catholicism and the Mediterranean Gothic reinvented and carried to paroxysms by Gaudí.'

On 19 August 1936, from his mountain hideaway in Cortina d'Ampezzo, in the Italian Dolomites, Dalí sent his friend Picasso a postcard keeping him up to date. No doubt toadying to Picasso, whom he knew hated the work of Gaudí, his tasteless exercise in shock employed to the full the famed Spanish black sense of humour and Dali's morbid curiosity – his adolescent *morbo*. 'The other day in Barcelona in the afternoon a friend of mine saw Mr Antoni Gaudí crossing the Via Laietana, he was being dragged along with a rope around his neck, he had a bad look about him (which was to be expected in his state) he has aged pretty well (he was embalmed) having just been disinterred. The anarchists always know where to find a

good pot of jam.' Back in 1900, Picasso had written to a friend, 'If you see Opisso – tell him to send Gaudí and the Sagrada Família to hell.' It is doubtful if during the intervening years he had in any way changed his mind.

Like most gossip, however, this muddled the facts. Another well-known observation on Gaudí's Sagrada Família, in a similar vein, was penned by George Orwell in *Homage to Catalonia*. Orwell, who arrived in Barcelona later that year, on Boxing Day 1936, described the Sagrada Família as 'one of the most hideous buildings in the world', and added that '[the anarchists] showed bad taste in not blowing it up when they had the chance'.

The great Gerald Brenan, a connoisseur of Spanish culture, was just as dismissive. With Anglo-Saxon cynicism he laid Gaudí low. In his book *The Spanish Labyrinth: An Account of the Social and Political Background of the Spanish Civil War*, he stated: 'That vast, unfinished, neo-Gothic church, the Sagrada Família, is decorated with stone friezes and mouldings representing the fauna and flora, the gastropods and lepidoptera of Catalonia, enlarged mechanically from nature so as to obtain absolute accuracy. Not even in the European architecture of the period can one discover anything quite so vulgar or pretentious.'

Orwell was closer to the mark than he knew. Following the initial wave of destruction, the FAI returned to the Sagrada Família later on the same day to dynamite the Nativity façade and erase Gaudí's monument forever from the city skyline. Either through inexperience or because they were persuaded by Sugrañes, Rubió or workers loyal to the project prepared to risk their lives, the

anarchists gave up, leaving the towers to stand amongst the smoking ruins.

It is a poignant reminder of how little had changed since 1909, when the poet Joan Maragall had written his compassionate article '*L'església cremada*' for *La Veu de Catalunya*. His hopes that both parties, the bourgeoisie and the workers, could find a common ground for reconciliation proved to be a sad reminder of a misplaced optimism. 'Enter, enter,' Maragall invited. 'The door is open; you have opened it yourselves with the fire and iron of hatred. By destroying the Church, you have restored the Church, which was founded for you, the poor, the oppressed, the desperate.'

The material carnage left behind was devastating enough. Many blamed Sugrañes's premature death in the summer of 1938 on his abject despair and sense of impotence faced with the impossibility of continuing the works. The bricks and mortar and abandoned rubble left on site must have been totally dispiriting, even heartbreaking.

On 20 July, or a few days later, the revolution would demand a human cost. Mossèn Gil Parés, the chaplain of the crypt at the Sagrada Família, who ten years earlier had sent a search party out to find Gaudí the night he was run over by a tram, was now a target for the FAI. He was tracked down and murdered on 26 July, found with seven bullets in his head. With ruthless efficiency Consol Puig, a teacher at the Sagrada Família school, and Clodomir Coll were also killed for having offered Gil Parés shelter. Ramon Parés, Mossèn's brother, founder of the Red Cross in Terrassa and right-wing politician, was gunned down the

following month screaming defiantly, '*España católica es inmortal*.' Six months later in January 1937, discovered hiding in a house with family members, Dr Francesc Parés, Vicar General of Barcelona and president of the Junta of the Sagrada Família, was assassinated. The hunt for the Catholic power structure and its sympathisers was relentless. In March, Dr Ramon Balcells, founder of the Caixa de la Sagrada Família, the Sagrada Família's savings bank, which had transferred its funds for safety to the City of London, was murdered in the Pyrenees en route to exile in France. Balcells, who had negotiated with the anarchists and paid blood money to ensure the safety of other priests, could sadly not secure his own life. Of huge spiritual importance to Gaudí was his confessor, the Oratorian Agustí Mas, who was based at the church of Saint Felipe Neri in the heart of the Barri Gòtic. Mas shared with the architect a passion for Gregorian chant and believed, like Gaudí, in the transcendent power of beauty. Jailed in February 1937 in the anarchist prison of Sant Elies, he was released the following month for a final *paseo* up to Montcada, where he was shot in the back of the head and thrown into a trench. In total, twelve people associated with the Sagrada Família were killed: a group that is now known collectively as the Twelve Martyrs of the Sagrada Família. They are, like Gaudí, in the process of canonisation.

Many of Gaudí's friends, including the Jesuit philosopher and historian Ignasi Casanovas, were also victims of the revolutionaries, who became increasingly violent as they retaliated following news of appalling Nationalist atrocities. Even Barcelona's Bishop Manuel Irurita, who was caught hiding in the Tort jewellery workshop disguised

as a worker, was executed. Caught between the contrary demands of immediate revolution or the more pragmatic necessity of focusing on an organised and centralised war effort, Barcelona soon descended into the paranoid chaos of a war-within-a-war that Orwell so poignantly described.

Perhaps it was a blessing that Gaudí was not alive to witness the devastation and the shattered dreams of trying to build a spiritual community that celebrated the humble working man and the value of handicraft, and one that at its very core professed its religious reverence for nature. The greatest loss to the Sagrada Família was that human sense of continuity and ownership that many of the builders had enjoyed.

As a project, the Sagrada Família was finished but not yet dead.

On 1 June 1939, in edition No. 7 of the *Hoja Informativa*, the Devotion published an information update to commemorate the thirteenth anniversary of Gaudí's death. In the headline article they concluded that had the architect been alive to witness those sad days of 1936 there was absolutely no doubt that he would have joined the long list of religious martyrs. Underneath the headline a photo showed the studio as Gaudí had left it behind; crammed with furniture, hanging lamps, drawing boards, spilling over with plans and drawing instruments, compasses, set squares, plaster maquettes and large-scale models that reached high up towards the ceiling, all of which no longer existed.

For the entire duration of the Spanish Civil War in the Republican zone, particularly in Barcelona, any

demonstration of religiosity or sign of bourgeois 'deca-dence' expressed in style of dress or otherwise was an invitation for violent repercussion. No substantial record of the wasteland that was once the Sagrada Família now exists. Once all the metal from railings, religious furni-ture and images had been scrapped and recycled for the armaments industry the site was left to deteriorate as a ruin for children to explore, for cats to scavenge, and the crypt below ground transformed into makeshift toi-lets with Gaudí's grave defiled as a dump for used sardine cans, broken bottles and other rubbish. Suspended across the four towers, covering the polychrome Hosannas that today invite the passing public to prayer, a large banner advertised '*Alistaos en las Juventudes Libertarias*', a call to join the FIJL, the anti-authoritarian Iberian Federation of Libertarian Youth.

By January 1939, it was clear that the Second Republic's last-ditch offensive of the previous autumn, at the Battle of the Ebro, had proved a costly failure. Barcelona was effec-tively doomed. On 15 January 1939 Tarragona fell and, eleven days later, on 26 January, the revolutionary city of Barcelona was entered by Franco's victorious troops. Ahead of the advance, more than 400,000 Catalans in fear of their lives fled across the border only to find themselves penned in behind barbed wire on the beaches of France; cold, hungry and exhausted with all their illusions shat-tered, to be employed as forced labour and future prey for the incoming Nazis.

Those who remained in Barcelona were either Francoist sympathisers or those who through inertia hoped some-how to survive the terrible storm of repression about to

be unleashed. Much of the fabric of Barcelona's Catholic Church had been destroyed. It was not just the symbolic Sagrada Família that lay in ruins. Almost forty churches had been totally destroyed and many convents completely burned out. Others had been gutted, stripped of anything that might be associated with their Catholic DNA, with religious images occasionally lined up and 'assassinated' in a symbolic firing line as if they were somehow alive. The empty cavernous spaces were transformed into repositories for war materiel, used as stables, shelters for refugees, as markets, cemeteries, ballrooms or, like the church of Bon Pastor, turned into garages, or, like Cristo Rei, used as petrol stores. Almost everywhere the archives and records had been torched in order to leave behind a *tabula rasa*.

On 1 March 1939, with Madrid still desperately holding out for the Republic, the administration of *El Propagador de la Devoción a San José* felt safe enough to publish No. 1 of their *Hoja Informativa*. Considering the damage to their temple it is not surprising that their rhetoric spoke of satanic criminal hordes and the enemies of God who had desecrated their sacred space. It was all too easy to fall into the trap of seeing Spain in terms of a simplistic Manichean duality of good versus evil. Having disinterred the Bocabella family the anarchists had left their corpses abandoned in the street for three full days. Beyond the language of recrimination, however, there was also hope. Mossèn Gil Parés had once asked Gaudí, 'What would happen if a war were to destroy the Sagrada Família?' and before he had finished the question Gaudí had responded, 'We would build it again.'

The new chief architect, whose first job was just to rescue anything from further damage, was Francesc de Paula Quintana, who had worked under Gaudí and Sugrañes since qualifying as an architect in 1918. Gaudí had admired his skills as a draftsman, which were close to 'perfection', but found him rather slow. Other colleagues, such as Joan Bergós Massó in an article entitled '*La bienhechora campechanía*' – the benevolent comrade – delighted in his constant good humour, his jokes and love of a good *tertulia*. A few years later it was Quintana who had been entrusted with curating the homage to Gaudí after his death in the Sala Parés in 1927. In the few commissions that Quintana completed on his own there was a distinct paring-back on decoration in keeping with the *Noucentisme* style that Sugrañes had also employed.

What was left of the workshops was in most places nothing more than the stone slabs on the floor under piles of rubble. Water pipes had been sawn through for the metal or smashed and split. The ceiling of the crypt was leaking and everywhere pools of stagnant water mixed with rubbish and ordure gave off a pestilential smell. Quintana was fortunate that José Brasó, who had worked at the Sagrada Família for the previous thirty years, was not too shaken by the terrible disaster and prepared to resume his job as foreman in charge of the clean-up.

Quintana's painstaking eye for detail and his slow pace were the perfect attributes for dealing with the task at hand. Old photos show shelf upon shelf of near-identical broken fragments of white plaster, which had been patiently collected and catalogued in order to rebuild a fraction of the original model. This would prove the most complex

of jigsaw puzzles, often with many different puzzles con-
fusingly scrambled up. The idea was that even from the
slightest visual information the team might eventually
extrapolate the whole structure. In a sense this could be
best described as the archaeology of the future.

The restoration process focused not just on the fabric of
the basilica but also the restoration of the values that had
been in danger of being lost. The *Hoja Informativa* offered
up its bimonthly homilies under the strapline '*Consideración
moral*', reflecting only too accurately the new mindset and
values celebrated by the Franco regime.

The *Hoja Informativa* was disgusted by the influx of
returning bourgeois celebrating their good fortune with
*cenas americanas*, their modern style of dress, with the
women smoking while sipping elegantly at their imported
cocktails and addressing each other with familiar nick-
names learnt abroad. The *Hoja* lamented, in an eter-
nal refrain, the sad loss of true Catholic family values.
Already the siren call of Hollywood from '*Yanquilandia*'
was tempting the young, *Hoja* warned ominously. It was,
in their opinion, a lamentable phenomenon attributable
to the amoral machinations of a Jewish conspiracy that
planned to lead their innocent children astray. The '*cow
boi*' with his revolver seemed preferable as a role model
to the peaceful shepherd, just as the colourful Apache war
bonnet was preferred to the *mantilla*-wearing aristocrat
with her elegantly carved *peineta*. Even in the mundane
and intimate areas of everyday life, the idealised *hogar* –
the mythic home – where the mother nurtured her
flock, the *Hoja* warned against the dangers of imminent
deracination.

With the death of Pius XI in February 1939, fresh winds were blowing through the Vatican. Encyclicals such as *Non abbiamo bisogno* (1931) and the two now famous encyclicals of 1937, *Mit brennender sorge* – With Deep Anxiety – and *Divini redemptoris*, had respectively highlighted Pope Pius XI's fears about the excesses and inherent racism of Mussolini's Italy, Hitler's Nazi state and Stalin's totalitarian regime. While his successor Cardinal Pacelli, who adopted the style of his predecessor as Pius XII, suggested a carefully calibrated continuity, his reputation has since suffered due to his polemical stewardship of the Catholic Church through the Second World War.

Most importantly, Pius XII's message *Con inmenso gozo* to the Spanish faithful on 14 April 1939, celebrating Franco's victory, spoke as much of conquest as it did of the hope of future reconciliation. In the case of Franco, the pope's message regarding forgiveness and mercy fell on completely deaf ears. Franco's preferred modus operandi was brutal repression which offered humiliation and forced labour as a cure-all, with extra-judicial extermination meted out to those who stood in his path.

Pius XII began his message:

With great joy We address you, most dear children of Catholic Spain, to express to you our fatherly congratulations for the gift of peace and of victory . . .

The designs of Providence, most beloved children, have once again dawned over heroic Spain. The Nation chosen by God as the main instrument of the evangelization of the New World and as an impregnable fortress of the Catholic faith has just shown to the apostles of

materialistic Atheism of our century the greatest evidence that the eternal values of religion and of the spirit stand above all things.

On Good Friday, 7 April 1939, in a defiant gesture against the scenes of total desolation that the Catholic faithful found all around them, a statue of the crucified Christ was brought in procession through the pouring rain to the exact spot where the Sagrada Família school had once stood. With due solemnity the statue was blessed. It was the symbolic first step on the long *Via Crucis*. From the ashes, the congregation was promised, there would once again rise a new church.

On a more practical level, with nowhere left in a vaguely suitable state for worship or to celebrate the mass, the *Devoción* was moved – until further notice – to the Dominican convent two blocks down the Carrer Mallorca on the corner of Roger de Flor. Slowly – peseta by peseta – the *limosnas* requested to finance Quintana and his team started to come in. Once again, the Llibreria de los Herederos de la Viuda Pla, down in Born, where Bocabella had started the whole enterprise back in 1866, was open for business, ready to accept donations.

What was remarkable was the continuing commitment to the project. Passing through a crucible of terror and appalling chaos, it had truly been a trial by fire. It was also obvious that there had been a catastrophic disconnect between the temple and the people it had been built to serve. They had rejected it violently. Faced with this painful revelation, the never-ending piles of rubble and the financial hardship, it is not surprising that many felt totally

dispirited. It was without a doubt the lowest point in the entire history of the Sagrada Família. As a private *Devoción* which existed thanks to the generosity of its benefactors and with no insurance to cover war damage, it is hard to see how they could use the begging bowl to recover the lost investment. The progress had never been faster than snail's pace, at best. And it is almost miraculous that the architects who had worked with Gaudí before 1926 were prepared to return after the Spanish Civil War and devote the rest of their careers to starting all over again, back almost at square one.

Throughout the 1940s work on the Sagrada Família effectively ground to a halt. Almost all its supporters' energies were focused on restoration of the damage, further research and deep reflection. This was not the time for large-scale construction projects, unless, like the Valle de los Caídos, they were underwritten by the state and employed slave labour supplied by defeated Republicans as part of Franco's policy of moral purification. Franco's desire to rival 'the grandeur of the monuments of old, which defy time and forgetfulness' was built on a scale to rival the Hapsburg El Escorial just a few miles up the road. This monument, built as a 'national act of atonement', while sharing with the Sagrada Família the Catholic concepts of sin and expiation, was on an altogether different scale. The Sagrada Família had no access to the state's coffers, the national lottery or unlimited stocks of building material and workers.

During the Second World War, despite the close ideological ties and debts he owed to Nazi Germany and Fascist Italy, Franco remained firmly non-belligerent. As

ever, his apparent indecision, wedded to cynical prag-
matism, proved effective as he teetered and teased with
his regime's demonstrations of shifting Anglophile or
Germanophile sympathies. Exhausted and shattered by
civil war, the country was not in a position to throw
itself headlong into the conflict. Spain was on its knees.
As Miguel Angel del Arco Blanco demonstrated so con-
vincingly in his article 'Hunger and the Consolidation of
the Francoist Regime (1939–1951)', during the 1940s
starvation was used as a weapon or as a crude carrot
and stick. Obedience was rewarded, while disobedience
meant little or no food on the plate. The reality described
in Paul Preston's forensic dissection *The Spanish Holocaust*
was for many a living nightmare, quite literally, hell
on earth.

At the Sagrada Família site, with all possibility of
playing an active role in the religious life of the parish
now put on hold, Quintana's patient leadership in the
studio was of central importance in keeping up morale.
His buoyant personality and expansive smile must have
been some consolation for his two colleagues Isidre
Puig Boada and Lluís Bonet i Garí. Although all three
were confirmed Gaudínistas, they all had other work
outside the Sagrada Família. Apart from his commis-
sions for new buildings in Barcelona, Puig Boada was
also responsible for restoring war-damaged churches
in the geographically extensive bishoprics of Urgell
and Solsona. Lluís Bonet i Garí, on the other hand,
was busy working on a twenty-one-storey high-rise,
the monumental Banco Vitalicio, a reinforced con-
crete behemoth on the stylish Passeig de Gràcia, which

proved an enormous undertaking. The tallest building in the city, the Banco Vitalicio was heavily inspired by the Chicago School. It couldn't have been further away in either its style or *mentalité* from the Sagrada Família. More importantly, Bonet i Garí was also the patriarch of a family who would all find employment at the Sagrada Família: his son Jordi Bonet i Armengol would take over as lead architect, his son Lluís was the parish priest, and his nephew Jordi Bonet i Godó would find work there as a sculptor.

In 1944, Quintana reorganised the Junta Constructora del Templo, who rubber-stamped his position as the director of works. Although nominally in charge, Quintana's period as director should really be seen as a coming-together of this trinity of talents. The most pressing issue, after the clean-up, the restoration of the models and securing the perimeter fence, was to forge ahead with the Passion façade. The most important aspect of the research was to investigate whether Gaudí's calculations were in fact accurate. The implementation of the design concept from drawing board to plastic reality would take the rest of the decade.

# THE ARCHAEOLOGY OF THE FUTURE

In 1951, the UN passed a resolution to resume full diplomatic relations with Spain. Despite Franco's closeness to the defeated Axis powers, the UN's volte-face was the first step towards the normalisation of Spain's relationship with the international community. At the height of the Cold War and midway through the Korean War, the United States realised that Franco's implacable anti-communism and his position as a bulwark against the Soviets was of huge geopolitical importance.

On 27 May 1952, the thirty-fifth International Eucharistic Congress opened in Barcelona with Franco's full support. After a long hiatus, the International Eucharistic Congress was the first to be convened since before the Second World War. By chance, the history of the congress, whose purpose was to celebrate the centrality of the Eucharist to the Catholic faith, had run in perfect tandem with the building of the Sagrada Família, predating the laying of the first stone back in the nineteenth century by just one year. In the intervening years the congress had grown into a huge event with delegates flying in from all over the world. More than 300 archbishops with a further 300,000 pilgrims were expected to transform the event into a massive

religious jamboree. Politics, however, was never far from the pulpit.

In front of a crowd of 100,000 the Cardinal Primate of Spain, Cardinal Enrique Plá Deniel, delivered a blistering attack on communism.

In a well-orchestrated display of support, all factories and shops were closed down to encourage Barcelona's million-strong workforce to join the 15,000 prelates who were expected to officiate at a whole host of public masses. As the papal legate Cardinal Tedeschini arrived at the bottom of the Ramblas below the statue of Columbus, the city's 400 churches rang their bells in celebration. El Caudillo, Francisco Franco, was expected to arrive by ship to attend the PR coup, while behind the scenes he was busy negotiating a concordat between Spain and the Vatican, which would be signed the following year.

With 'Peace' as the congress's central theme, Pope Pius XII joined the delegates by radio broadcast from the Vatican, where he led the congregation in a prayer for union and concord so 'that the lily of peace may blossom forth on our barren and desolate earth'.

In preparation for the congress, the Sagrada Família had been provided with some cosmetic improvements including a large sweeping ceremonial staircase in front of the Nativity façade and a battery of floodlights to bring its dramatic silhouette alive at night in order to rival the new bronze statue by Miret which crowns the Tibidabo.

On 30 May, at the Sagrada Família, more than twenty bishops assisted by 150 priests administered the sacrament to 20,000 women who had queued patiently in line in

front of Gaudí's Nativity façade. Not since Gaudí's funeral had so many devotees attended such a special event.

Of huge symbolic importance was the presence at the congress of New York's Cardinal Francis Spellman, who represented yet another step towards the normalisation of Spain's relationship with the US and signalled that its international pariah status was a thing of the past. Spellman, nicknamed the American Pope, his chancery the Powerhouse, was the consummate fixer, having some years before been assigned the task by Pius XI of smuggling his encyclical *Non abbiamo bisogno*, which criticised Mussolini, through Italy and on to Paris and the international press. He was also a rabid anti-communist who lent his full support to McCarthy's witchhunts of subversive 'reds' in 1953. His views on public morals and the pernicious effects of Hollywood would have sat easily in the pages of the Devotion's *Hoja Informativa*.

Hard on the heels of the successful International Eucharistic Congress, Spain's thawing relationship with the United States received a more official imprimatur with the signing in September of the Pact of Madrid, which promised necessary financial aid.

Everyday life in Franco's Spain in the early 1950s was one of terrible hardship. The official economic policy of autarky – self-sufficiency – suffocated growth. The system of *estraperlo* (corruption, named after a famous case during the Second Republic) and a flourishing black market led to immense disparities in wealth distribution. Massive internal migration was the result of subsistence farming becoming completely unsustainable. The knock-on effect in cities like Barcelona was immediate. The

huge influx of immigrants from the south, given the catch-all epithet *Murcianos*, created shanty towns with quaint names like La Font de la Mamella and Can Valero on the slopes of Montjuïc, tempted there by the promise of milk and honey. The reality was less romantic. At Can Valero almost 30,000 people shared seven public taps. In Can Valero, at least, vulnerable families were given enormous help by the Carmelite father José Miguel, who helped fund a school and a dispensary.

On any spare land makeshift towns sprang up. From the Barceloneta heading north along the beach for five miles to where the Besós river debouched into the Mediterranean, tens of thousands lived in shacks in the legendary Somorrostro.

Not far from the Sagrada Família, on the wrong side of the railway tracks that ran alongside the Ronda de Sant Martí, the notorious shanty town of La Perona grew up, named after Eva Perón, who visited it in 1947, whose inhabitants naïvely believed that her personal lar-gesse would help them start a new life. The 1950s was a period of dramatic change and widespread poverty. It is not surprising that the Sagrada Família, whose future was entirely reliant on donations, would also experience a restricted budget. The brutal conflict of the Spanish Civil War, however, was unlikely to be repeated despite the grinding poverty for a raft of different reasons: firstly, the Franco regime ruled through a toxic mixture of fear and zero tolerance; secondly, many of the newcomers came from Andalucía and Castile, lands that were conserva-tive in tradition and where there was still a deep-rooted respect for the Church; thirdly, a whole generation of

Republicans had fled into exile; and last of all, those that remained suffered from profound demoralisation and sheer exhaustion.

A year after Cardinal Spellman's visit, a very different American visited Barcelona to witness another reality, a world away from the large PR extravaganza that had surrounded the congress. In autumn 1953, Tennessee Williams passed through Barcelona, en route to Morocco, and was shocked by the gaping divide between the rich and poor. While in Barcelona, he had been chewing over his Pulitzer-winning play *Cat on a Hot Tin Roof*. The Big Daddy character, played by the great Burl Ives in the subsequent movie, reminisces to his son Brick over those days back in Barcelona: 'The hills around Barcelona in the country of Spain and the children running over the bare hills in their bare skins beggin' like starvin' dogs with howls and screeches, and how fat the priests are on the streets of Barcelona, so many of them and so fat and so pleasant.'

There is a profound irony in the fact that when denounced as a communist and pulled up in front of McCarthy's inquisition, the notorious House Un-American Activities Committee, Ives decided to save his skin by informing on some of his friends. Cardinal Spellman would surely have approved.

A couple of months after the International Eucharistic Congress drew to a close the Sagrada Família received even more attention. It is quite possible that the congress had been instrumental in reigniting a broader interest in Gaudí's work.

On 31 July 1952 Nikolaus Pevsner, the high priest of architectural history in the English-speaking world, in a

series of broadcasts on BBC Radio 3, finally allowed himself to be seduced by Gaudí's flights of fancy. His admission that the English had unfairly swept Gaudí aside and kept him firmly out of the official canon was perhaps a recognition of his earlier scepticism, and he went on air to make amends. His description of the Sagrada Família was wonderfully evocative:

The façade culminates in four (narrowly spaced) tall conical or sugar-loaf towers in pairs of two and two close together. They rise and taper, first consisting of tall columns, then of taller piers with spirally set horizontals (or) transomes if you like between and finally ending in forms of no architectural precedent whatever, spires of crustaceous form, details sometimes like the jazzy light fittings of 1925, sometimes like celestial cacti, sometimes like malignant growths, sometimes like the spikes of bristly dinosaurs. And the whole of these spires above the conical, brown stone towers is made of glazed faience with an incredible technique . . . this description may sound to you crazy. Well, of course it is that. It may sound to you also not religious – but there you are wrong, because you are English and Protestant, whatever you call it. But it may sound to you vulgar too, and that it also isn't. It has, at least in my opinion, all the ferocious power of conviction which baroque architecture can possess. It is fabulous, it is miraculous, it hits you hard, it gives you no peace, it does not let go of you, and for that very reason it is proper for the church, rousing you to prostrate yourself and to worship. So at least it must have seemed to the Catalans; for

the building goes up out of the donations of the people, and the people, I can assure you, adore it.

Finally, after almost two decades, Pevsner was making up for his sin of omission. In Pevsner's seminal 1936 *Pioneers of Modern Design*, Antoni Gaudí, the most radical and groundbreaking of all architects, had been left out altogether.

It is ironic that while it had taken Pevsner until the 1950s to finally fall for what he described as Gaudí's 'phantasmagoria' and to kickstart a wider appreciation, in Barcelona itself there were the beginnings of an organised lobby that wanted to put an end to work on the Sagrada Família. Pevsner, however, had also been alert to the difficulties that might lie ahead:

One more word. Gaudí died in 1926 and since then the Barcelonese have pondered over the problem of what to do with the Sagrada Família. I told you, no more is up so far than about one eighth. What can be done? It is obvious to me that one can't, not even with all the dedicated lunacy of Spain, continue à la Gaudí. He was, you will now agree, the most personal, inimitable of architects. He kept only the fewest of designs or models. Every detail was decided face to face with the block and the surface. So there seem to me only two possible answers, one more tempting, the other (probably) more constructive. You can leave this cliff of a church as a ruin, plant the rest of the site sensitively and enjoy the building in future as the hugest of all

*custodias* – that is the Spanish name for (those) tower-shaped monstrances you see in the cathedrals. Or you can trust in the Spanish genius and make a competition inviting designs not in the style of Gaudí nor in the so-called International Modern Style. Perhaps amongst the talented young architects of Spain one would come forward as fervent as Gaudí, and as original as he.

What Pevsner, in the language of the 1950s, understood as 'the dedicated lunacy of Spain' made no allowance for the totally determined members of the Devotion and its junta, who planned to continue the works as planned. Without a deeper knowledge of how the Gaudí inheritance had been passed down through an unbroken line of faithful assistants, Pevsner could not possibly have understood the real sense of continuity that existed. Nor could Pevsner, without privileged access to the painstaking work of Quintana or that of his colleagues and future successors Lluís Bonet i Garí and Isidre Puig Boada, have seen how faithful they were to Gaudí's original plans. Isidre Puig Boada's monograph *El temple de la Sagrada Família*, published in Catalan in 1929, was the most authentic way to access reliable information but it is doubtful that Pevsner knew this work.

At last Gaudí was winning official favour in the academic world. In 1956, the Cátedra Gaudí was formed at the Escuela Técnica Superior de Arquitectura de Barcelona to promote, understand and protect his legacy and archive. In 1958 the American academic George R. Collins visited Barcelona to study Gaudí's work in depth, which would

lead in 1960 to the publication of his monograph *Antonio Gaudí*, the first serious study in English. From his base as professor of history of art at Columbia University, New York, Collins played a central role in the rehabilitation of Gaudí's international reputation. Collins' chosen path to securing Gaudí's contemporary relevance to the Unites States cleverly utilised the debt that great public buildings like Boston Public Library, Massachussett's State House and New York's Grand Central terminus, among many others, owed to the Catalan vaulting technique.

In the same year, 1960, Conrads and Sperlich's *The Architecture of Fantasy*, including works by Gaudí, was published, as too was Josep Lluís Sert and James Johnson Sweeney's monograph *Gaudí*. The studies took very different approaches to Gaudí's work. Conrads and Sperlich focused on the phantasmagoria, while Sert, famous as dean of design at Harvard and a celebrated pioneer of the Catalan International Style, chose to look at Gaudí as an empirical seeker of simple construction solutions. Importantly, these diverse contributions indicated a growing consensus that Gaudí was a master worth taking seriously.

In 1964, a Gaudí exhibition at Richmond's Virginia Museum of Fine Arts prepared the ground for his debut in 1966 at New York's Museum of Modern Art.

While Gaudí had now become the subject of serious architectural study, his growing reputation also coincided in the late 1950s and early '60s with the beginnings of the tourist boom that would kickstart the 'Spanish Miracle'. Gaudí was a perfect figure for the counterculture's hippy ethos. On the surface he was an exact fit for

all the clichés of Spain as the breeding ground of sur-realist genius. It was a simplified image that totally dis-regarded his deep Catalan cultural identity and his fervent religiosity.

In 1954 work started in earnest on the deep founda-tions for the Passion façade. The realisation that work on the Sagrada Família had finally moved on from the research laboratory stage to concrete action focused the junta. In 1955 the first full-scale public fundraising drive proved surprisingly successful.

The first free-standing column in the interior of the Sagrada Família, with its signature corkscrew twist, was put in place in 1957. More hours, as we will see later, were expended on computing and understanding Gaudí's care-ful calculations for the columns than on almost any other aspect of the Sagrada Família build.

In 1958 the artist Jaume Busquets completed the final sculptural ensemble for the Nativity façade's central Charity portal. A highly skilled all-rounder, Busquets had been a part of the traditional Amics de l'Art Litúrgic, a Catholic collective. Despite his influential position as the first director of the prestigious Massana art school, Busquets could also do Christian humility to perfection. Over the years Busquets had advised on the stained-glass decoration for the Sagrada Família crypt. Jaume Busquets' holy family sculpture, while showing off his consummate gifts as a craftsman, is also genuinely moving. The Virgin Mary, bent over the nude Christ child, lowers the baby into a basin bath with a tenderness familiar to any mother. Looming high overhead, the scene draws the viewer in with its engaging simplicity.

In 1961, with ever-increasing numbers of visitors, it became obvious to the junta and the three architects that a small museum detailing the building's history, its aims and future aspirations might help to educate the public. The first of many variations, the small museum proved to be a significant draw. If the museological process had helped to refine the architects' ideas, it also gave rise to some vocal opposition.

On Saturday 9 January 1965, in an open letter to the editor of the Catalan newspaper *La Vanguardia*, an impressive collection of architects and intellectuals co-signed their opposition to continuing work on the Sagrada Família. Many, like the architects Òscar Tusquets, Ricardo Bofill and Oriol Bohigas, belonged to the talented young generation of liberal intellectuals branded the Gauche Divine, a cosmopolitan group which also included the homosexual poet Jaime Gil de Biedma. As stylish members of the Catalan *burgesia* they were constitutionally and ideologically opposed to the brutishness and vulgarity of the Franco regime, and for many of the brilliant Gauche Divine the continuation of work on the Sagrada Família represented at best an anachronism, at worst a ludicrous ahistorical travesty.

Other co-signatories, however, also included artistic heavyweights such as Joan Miró and Antoni Tàpies and two of the greatest living architects of the twentieth century, Alvar Aalto and Le Corbusier. Bruno Zevi, the Italian architect, theorist and founder of the Association for Organic Architecture, apart from his highly vocal stance against classicism, found the concept of other architects bastardising Gaudí's temple pure anathema. Many of

the signatories had their own agendas, but it was clear that amongst some of the more progressive circle of Catholics, the idea of spending money on a huge white elephant instead of pastoral care was deeply unpalatable. The concept of an expiatory temple, they believed, was both outdated and irrelevant. What they all put their signatures to was a letter which stressed that Gaudí's creative process often relied on changes that were effected during the actual build. What the letter also highlighted was that Gaudí's work had a very pictorial, narrative aspect to it and was in itself a work of art. No one would ever think of finishing off a painting or a sculpture, the letter argued, without the artist involved. Why then finish a building? Antoni de Moragas, the dean of COAC, the College of Architects in Barcelona, and other professionals expressed the view that the Sagrada Família served none of the city's urban needs and that the works should be frozen until its future was vigorously debated.

Reading between the lines, of course, what many of the signatories really objected to was the creeping evolution of what they regarded as nothing better than a religious theme park.

Òscar Tusquets would later repent signing the *La Vanguardia* open letter, but the most unlikely signatory was the sculptor Josep Maria Subirachs, who would subsequently recant and then devote the last two decades of his life to sculpting the Passion façade.

The debate created by the open letter had little real effect on the Sagrada Família, as its status of private *Devoción* effectively protected it from outside interference. In fact, in the following few years donations increased rather than

dried up. Of more significance was the death in June 1966 of Francesc Quintana, which left Puig Boada and Bonet i Garí as co-directors.

In November 1976 the façade, quite literally the skeleton, of the Passion façade was topped out with its four bell towers echoing those across the transept at the Nativity. The Sagrada Família was beginning to create the illusion of a rising mass, like a dramatic wedding cake.

Strangely, despite the progress and the growing international attention that came in the wake of tourism, the reputation of Gaudí in Catalonia's official architectural circles was at an all-time low. It was almost as if foreign approval questioned the validity of what he had done. Architectural students in Barcelona who studied during that period remember that Gaudí had become a figure of ridicule whenever mentioned, if mentioned at all.

In the 1980s, with abstract art already a common language well into its third generation, and with pop art already being replaced by the cold, detached, cerebral art of conceptualism, the religious, almost nineteenth-century realism of the Sagrada Família looked dated. Between 1981 and 1982, the sculptor Joaquim Ros i Bofarull, a disciple of Pablo Gargallo, completed the two separate groups of the Adoration of the Magi and the Adoration of the Shepherds which flanked the Charity portal of the Nativity façade. The figures are strangely static and wooden. The subject should suggest surprise and wonder, as the two groups representing the rulers and the *pueblo* join together to witness the revelation. The effect, created by Ros i Bofarull, is more like a hackneyed theatre backdrop.

In 1983 with Puig Boada and Bonet i Garí now both in their nineties, they finally retired from their duties in favour of the architect Francesc Cardoner i Blanch, who would turn out to fulfil his role merely as a caretaker-director before Bonet i Garí's son, Jordi Bonet i Armengol, took over in 1985. From 1979 the architectural team was supplemented by the arrival of the New Zealander Mark Burry, an architectural graduate from Cambridge University who was intrigued by Puig Boada and Bonet i Garí's ability to carry on despite the apparent absence of plans. Though Burry was just finishing his BA thesis, they took the unusual step, very much in the spirit of Gaudí, of inviting the complete novice to join their team. What Burry quickly learnt from his elder peers was that Gaudí's plans obeyed complex rules of geometry that, once applied to the existing material, could be patiently recreated. What the geometry gave you, most importantly, was the building's DNA.

At first, with all the enthusiasm of the young apprentice, Burry laboriously drew up by hand a new set of working blueprints. When Bonet i Armengol took over, Burry was just at the point of making the quantum leap over to the CAD programs that had helped the manufacture of the complex shapes needed in the aeronautical industry for the Concorde jet. Having combined his MA studies with his position as architect-researcher, Burry in 1989 moved across to the world of computer-assisted design. It would prove a revolutionary moment in the history of architecture. What was curious, and again so typically Gaudínian, was the interface and tension on site between the latest technology and a sculptural

tradition that had hardly changed since the birth of time. The clumsy toolkit of hammer and chisel was now in competition with an ever-evolving explosion of technological advances that today sees 3D printing as the total norm. Jordi Bonet was wise enough to see the value of both.

Without a doubt the most polemical aspect of the Sagrada Família project was the acceptance in 1986 by the sculptor Josep Maria Subirachs of the commission for the Passion façade. Subirachs was the first to admit that his work would be in no way an imitation of Gaudí's: in fact, he demanded it as a condition for signing the contract. Where Gaudí used organic forms and the curves of grace that he associated with God, Subirachs is hard, cold, angular and uncomfortable. The bare bones and structure of the Passion façade had been carefully thought through by Gaudí, sketched out in elaborate detail on the drawing board. Since the 1950s work on the façade had been brought to conclusion by the trio of architects Quintana, Isidre Puig Boada and Lluís Bonet i Garí.

Gaudí had once explained to his future biographer Joan Bergós that 'in contrast with the Nativity façade', which was deliberately 'decorated, ornamented and turgid', the Death façade, as he chose to call it, was to be 'hard, flayed, as if made of bones'. He was quite clear on the effect it should have on the viewer. He wanted it to 'instil a sense of fear in people'. 'To do this,' he explained, 'I shall not skimp on the chiaroscuro, projecting elements and voids, everything that results from the most gloomy effect. What's more, I am prepared to sacrifice the building work itself, to break arches, cut columns, all for the

purpose of giving an idea of how bloody sacrifice is.' It is particularly poignant that when Gaudí was designing the Passion façade he was recuperating from a serious, potentially fatal, attack of brucellosis and depression up in the Pyrenees, in Puigcerdà. Down in Barcelona, his only living family member, Rosita, was drinking herself to death.

What is obvious is that Gaudí was working on the boundary line between sculpture, architecture and autobiography, looking at the nihilism of the subject as dictating directly to the creator the evolution of the pathetic ensemble. Adopting this criteria, Subirachs' interpretation of Gaudí's wishes is perhaps better than it looks. To be fair to Subirachs he had accepted the commission only on condition that he would not attempt to imitate Gaudí. Instead he wanted something 'simple and cinematic'. Heavily influenced by Henry Moore, Subirachs would suffer from the same weakness as the Englishman of pandering to institutional taste. And like Moore there was a marked tendency towards endless repetition masked by the illusion of modernity as an instantly recognisable studio style. His lantern eyes, hollow cheeks or an angular nose are just some of the signature details subsumed under his palatable pre-packaged flirtation with abstraction. The all-over sparrow-pecked or rough plaster finish is an artful disguise for a lack of modelling. Less often mentioned is Subirachs' debt to the far more talented Antoni Tàpies and Eduardo Chillida, and his weak reworkings of sculptural ideas brilliantly essayed by Jorge Oteiza. If judged against his peers, Subirachs is certainly in a different league. However, to judge him like that is to do him a disservice. The comparisons, however, do

explain why Subirachs became a whipping boy and an easy target for art critics who judged him against the grit and authenticity of genuinely avant-garde pioneers. For the art critic Robert Hughes an encounter with Subirachs' work was thoroughly dispiriting, but not for the reasons that the sculptor had hoped. 'One cannot contemplate the progress of this work without a sinking heart,' Hughes bemoaned. With his hackles raised and at his most acerbic, Hughes carried on to dismiss the new sculpture at the Sagrada Família as no better than 'rampant kitsch'. For Hughes, Subirachs was a mere dealer in second-hand aesthetics.

What some critics have discerned in Subirachs' sculptures, with their hollowed-out cheekbones and their lifeblood seemingly drained away, is spiritual atrophy accompanied by a marked tendency to manufacture a seductive cocktail out of the twin doctrines of miserabilism and populism. The resulting works all too easily slip over into the realm of the mawkish.

Right from the very beginning, Subirachs' work on the Sagrada Família — although uniquely his — had to follow a strict narrative that demanded both popular appeal and a generous reach. Legibility and appropriate atmosphere are of key importance. Gaudí had wished for an effect that was 'hard, flayed, as if made of bones', and with this in mind, Subirachs certainly delivered.

Gaudí's design for the Passion façade begins with a series of inclined pillars that look like anorexic versions of those in the Park Güell. The canopy high overhead is like a gigantic baldachin or dust-catcher on a medieval *retablo mayor*. Daniel Giralt-Miracle in his *Essential Gaudí* likens the columns to the trunks of the sequoia, one of the

oldest living organisms on earth, some actually predating the drama that unravels on the façade below. From the Last Supper, through other scenes that include Judas's Kiss, the Ecce Homo, Longinus on Horseback and the Crucifixion, Subirachs takes us on a serpentine meandering walk up to Golgotha. At ground level, wrapped around the central column and within our touch, stands a larger-than-life depiction of a tortured humiliated Christ midway through suffering his flagellation at the hands of the Roman soldiers. Subirachs' façade demands that we drop our aesthetic armour, momentarily, and allow ourselves to follow the story in all its detail.

One of the details that immediately draws our attention is the 'magic square' wherein all the rows of numbers compute to a total that always arrives at the symbolic number thirty-three – the age of Christ. Open to a myriad of interpretations wandering through a minefield of cod maths, Masonic ritual, alchemy and the occult, Subirachs' magic square is a diversion that is certain to encourage as many conspiracy theories as those surrounding President Kennedy's death. Like the famous labyrinth in Chartres or Dürer's depiction of a magic square in his wonderfully enigmatic engraving *Melencolia I*, where the magic constant is thirty-four, we will never exhaust the need to construct elaborate conceits. It is human nature to search for reason in a world of chaos. If nothing else, by leading us to Dürer's *Melencolia I*, Subirachs makes a fascinating allusion to the image of Gaudí at work.

Dürer's brooding angel, with knitted brow, seated amongst the compasses, polyhedron and perfect sphere, is a perfect stand-in for Gaudí, alluding directly to the

Pythagorean belief in the centrality of numbers and form in the cosmos – a large part of the subject matter of the Nativity façade across the other side of the transept. Here he is – like a twentieth-century Leonardo da Vinci – troubled, questioning and, like Dürer, intent on proving the symbiotic relationship of art, mathematics and science while employing all his ingenuity and knowledge in pursuit of architecture's Holy Grail. It is a perfect metaphor for Gaudí's introspective soul, which never stopped questioning his faith or the need to transform personal suffering into a truly moving art. The Passion façade, for obvious reasons, is Gaudí and Subirachs' darkest hour.

In the same year that Subirachs accepted the commission for the Passion façade, in 1986, work began on laying the foundations for the nave and aisles. Up until the millennium, work would continue on the body of the temple as the walls and vaulting of the nave and apse started to give a real sense of the whole. With the passing of 2000, work on the Sagrada Família dramatically changed gear. Mark Burry and Jordi Bonet could now take full advantage of all the advances in computer analysis, laser cutting and robotisation. While the technology was Burry's specialist area it never diminished his respect for Gaudí's immense creativity. Far from it. Burry felt increasingly humbled that what the computer was feeding back to them confirmed the accuracy of Gaudí's calculations, which somehow miraculously he had computed almost entirely in his head. For the scientist, architect or amateur *aficionado*, this was one of the most exciting phases in the Sagrada Família works. Visitors were allowed on site as the cranes and builders worked on unhindered. What they got was an insider's view.

In 2001 the Sagrada Família school building was restored and repositioned on the corner of the site, and was transformed into a display case for a deeper understanding of the Gaudínian style. A whole new vocabulary had to be learnt. For the layman who could grasp the efficiency and beautiful simplicity of the catenary arch the complexities now unravelled. Conoids, for instance, are the shapes created out of straight lines running parallel to a directrix plane fanned out to meet a single axis. Or, to be less precise, a certain type of curved surface whose shape has the beauty of a perfect wave. Words, however, are more easily replaced with graphic models or with a geometrical equation. When conoids are multiplied they can form a parabolic conoid, which makes its first dramatic appearance on the roof of the Sagrada Família school with its wonderful undulating waves of tile. It is both economical and fantastically elegant. Perhaps Stefan Hildebrandt and Anthony Tromba can help us here with the simple analogy they use in their fascinating book *The Parsimonious Universe: Shape and Form in the Natural World*. For understanding Gaudí's language of form we should return to our innocent childhood games. Take a bowl of soapy water and play around with a pair of wire rings. Pull up the surface with one. Or stretch a transparent glistening film between the two. Within minutes you will be making shapes with names as complex as hyperbolic paraboloids or the hyperbolic hyperboloids that look like elegant funnels which Gaudí would use to puncture the Sagrada Família's roof to illuminate the nave below. In the towers, one of which was completed in Gaudí's lifetime, the stairs sweep up in a simple elegant helicoid like

a twisting snail's shell, as in the Great Mosque in Samarra. In some of his works he had gone for the more complex double helix – employed by da Vinci at Chambord – and later identified by Crick and Watson in 1957 as the shape of DNA. Had Gaudí been alive he might have responded, 'But, of course!'

The transformation of these geometric formulae to a computer was not just a time-saving exercise; it also opened up infinite possibilities. Burry's contribution has radically changed the parameters of architecture.

The story of the Sagrada Família is also the history of changing technologies. When Gaudí embarked on his career in architecture, his was the first generation to use photography as a vehicle for taking a virtual journey around the glorious universe of different styles. As armchair architects the world's variety lay at his generation's feet. More than 130 years later, materials, techniques, technologies and communications have radically changed. Mark Burry is based in Melbourne, where he holds the post of professor of innovation and director of the Spatial Information Architecture Laboratory at RMIT University. As founder director of the RMIT Design Research Institute his responsibilities are daunting. However, by commuting to Barcelona on a frequent basis and through computer linkup he can be 'virtually' permanently on site. Considering his experience and field of expertise it comes as no surprise that Burry has worked as a consultant for Arup, Foster and Gehry on various occasions. Transforming fantasy forms into plastic reality offers limitless scope for our built environment, as architects like Zaha Hadid have demonstrated so well.

Work continued on the Sagrada Família, and dissenters gradually melted away as they were confronted with the inevitable. Work was not about to stop with so much invested in the project. Gaudí studies had built momentum with specialists from the Netherlands such as Jan Molema and Jos Tomlow, the German experts Arnold Walz and Rainer Graefe and Leonid Demyanov from Moscow, amongst many others, joining Spanish and Catalan experts to dissect and debate his talents and revolutionary techniques.

In 2002, with the celebration of the Año Internacional Gaudí, 150 years after his birth, Gaudí studies turned the corner and became mainstream. Daniel Giralt-Miracle's enthusiasm and subtle diplomacy managed for the first time to unite almost every cultural institution in Catalonia and Spain to celebrate Gaudí's genius wherever he had worked. For Gaudí enthusiasts, 2002 proved a watershed. For the Sagrada Família it proved a godsend. The Gaudí boom, as we know it today, would provide the basilica with an income stream from tourism that secured the ambitious plans to finish it on time to celebrate the centenary of Gaudí's death in 2026.

It was, at last, possible for the visitor to visualise Gaudí's final plans as a reality rather than as a distant dream. Details sparkled in the light. Although high above, the viewer could see clearly blown-up renditions of autochthonous fruit as visually ripe metaphors for the human soul: orange persimmons, heaped chestnuts, juicy figs, almonds, blood-red cherries, blushing peaches, black prunes and golden medlars spilling over in plenty like the fruit stalls at the famous Boqueria market or Bosch's *Garden of*

*Earthly Delights*, where fruit are the embodiment of fleeting earthbound and sensual pleasures. But Gaudí's message is radically opposed to that of Bosch. Indeed, it is far more likely that Gaudí was thinking of the tree of life, as described in the Apocalypse, which produced a different fruit for every month of the year to cure all ills.

The Japanese sculptor Etsuro Sotoo, who left Japan for the honour of working on Gaudí's masterpiece, carefully carved these starbursts of colour over several years. For Sotoo the symbolism was as simple as it was profound. In a lecture at Fordham University, New York he elaborated on his ideas: 'At the top of everything there's fresh, ripe, colourful fruit with no leaves because when our body gives up, our soul rises. When a person has heard a lot of good words and has read a lot of good books, his soul is ripe fruit, but up there there are no words; you don't need any words.'

Inside the basilica the columns branch to form trees which lead the eye up to a canopy of vaults that Gaudí hoped would make us think of a natural shelter of leaves where light could break through. On the exterior, alluding back to the internal structure and upward growth, the piles of fruits illustrate nature's bounty.

What Gaudí had taught Sotoo was that the spirituality of art might offer access to a deeper faith. And so it proved for Sotoo. Over more than three decades, until the present day, Sotoo has carved his way towards helping shape the Sagrada Família's identity. On the Nativity façade Sotoo added a choir of fifteen angels who, like sacred muses armed with their panoply of popular instruments, from harps to bagpipes and the exotic

sitar, celebrate and bear witness to the birth of the Saviour. As happened so often before with Gaudí's other works, when he was still alive assistants like Jujol had been trusted to make their own mark in the spirit of the overall design. And Sotoo has continued in a similar vein, mining the same rich seam with singular carvings in durable stone.

Once again viewers step back to take another look. As eyes are pulled up towards the pinnacles, the silhouette begins to fill out and take shape. Like an elaborate wedding cake, towers rise so that, according to Gaudí, 'the exterior will be harmonious with the interior with a view to ensuring that a pyramid form prevails'. Eighteen towers in total will crowd together and push up in unison like a family in stone. Crowning the Passion, Nativity and the as-yet-unfinished Glory façade, will be twelve towers measuring between 98 and 120 metres and acting as giant finials bordering the central spatial drama. On each corner of the crossing will be four towers dedicated to the Evangelists: Matthew, Mark, Luke and John, crowned with their attributes, the angel, lion, ox and eagle. These are planned to rise to 135 metres, in perfect symmetry. Over the apse, only slightly lower and crowned by a star, will rise a tower dedicated to the Virgin Mary. The final central tower, rising to a vertiginous 172.5 metres, is dedicated to Our Saviour, Jesus Christ. The crowning detail Gaudí planned is a giant four-armed cross from which, at night, like a moral compass, brilliant searchlights will illuminate the way and remind us always of Christ's mantra, 'I am the light of the world.'

Inside and out, sculptural ensembles, dedications to saints and sees alongside carved motifs and narratives in stained glass form a rich lexicon of liturgical cross-references that would take a lifetime to unpick. The architect in us marvels at the incredible ambition; our inner sculptor at the host of details that fill and overload the façade with a kind of fascinating medieval *horror vacui*; our historian struggles to make sense of the contradictions that blend future, present and the distant past; while the devout Catholic broods over the powerful message and mission that the building avows.

For mathematicians the Sagrada Família offers an opportunity for endless contemplation and not a little scratching of heads. One of Gaudí's favourite buildings while still a student was the romantic Alhambra, a Nasrid palace complex that, according to Robert Irwin, may well have been inspired by Basra's esoteric tenth-century society the Brethren of Purity. The Brethren believed that 'the science of numbers is the root of other sciences, the fount of wisdom, the starting point of all knowledge, and the origin of all concepts'. For them, seven was the perfect number, and the human soul travelled through seven heavens on its transit towards God. Part of the Alhambra's enchantment lay in its use of the square root to create a hard-to-discern intimate harmony between all its parts. Close, but not exactly the same, was the relation of the head to the human body, which approximates the Golden Section. For Gaudí, of more importance was the biblical resonance of seven in terms of the creation and particularly its proliferation in the Book of Revelation.

Gaudí had often employed a module as the defining measurement for an entire structure; sometimes, as

in the Casa Vicens, this might come from something as banal and practical as the width of a tile, or, as in Mataró, the length and width of a humble plank of wood. At the Sagrada Família the module was exactly 7.5 metres, the width of an aisle. Almost all the other measurements are multiples of that defining module: the nave its double at 15 metres; the nave plus the four aisles 45 metres; the height of the aisles 30 metres; the height of the nave 45 metres; 60 metres across the entire transept, with 60 metres as the defining height of the vault over the crossing. With its symbolic human scale – approximating to the Golden Section – which Gaudí described as the 'tree-man', he was convinced it would imbue the space with a sense of harmony. A module, however, can be multiplied an infinite amount of times. The initial measurement, human in scale, can explode into a gigantic, almost terrifying space. For the generation of architects following Gaudí's death the discovery of how this module functioned facilitated their interpretation of this entire design. There may have been 'providence' at work, as Gaudí had claimed, but he also left almost nothing to chance.

The disciplines of geometry, mathematics and engineering are certainly legitimate ways to understand the structure of the Sagrada Família. However, for Gaudí the essence of the building was how the form followed its liturgical function. The Sagrada Família, like the Bible, was there to be read again and again to reveal the secrets of its divine message. Gaudí's basilica, built on the foundations of an expiatory rationale, revealed a Catholic dogmatism that was also linked to a peculiar mysticism and an almost pantheistic reverence for

nature. It is almost certain that Gaudí also thought of the building on a millennial scale, as the great temple to lead Catholicism into the future and function as a lighthouse for a new age.

In his tightly argued thesis *La Sagrada Família según Gaudí* Dr Armand Puig i Tàrrech, ex-deacon of Catalonia's faculty of theology, has proposed various routes through the building in order to make sense of Gaudí's spiritual labyrinth. Considering the troubled history of the Sagrada Família and the deep trauma of 1936, it is not surprising that Dr Puig should invest the bricks and mortar with millennial anxieties and fears. For him, to see only the spatial drama of the building is to ignore the message encrypted on and within its walls.

According to Puig, the Sagrada Família is nothing less than Gaudí's attempt to build a New Jerusalem, whose overriding message is the pursuit of universal peace. Surrounded at ground level by its cloisters, which hug the perimeter wall, the Sagrada Família rises like a single city unit or an exotic dreamscape, reminiscent of those medieval miniatures that illustrate the rare Beatus manuscripts so particular to Spain. To cross the threshold is to enter a sacred space.

The Sagrada Família functions both as Christian allegory and as a temple for prayer. The innocent first-time viewer might not understand that the building is so highly charged. Even curved shapes like the paraboloid generated from three straight lines were seen as powerful metaphors for the trinity of Father, Son and Holy Ghost. All around the visitor is surrounded by signs and symbols that build up, bouncing meaning off each other, sticking like

molluscs to a ship at sea. Slowly at first, according to Puig, the Christian mysteries gradually unfold.

The first route proposed by Puig is the *Via Humanitatis*, running from the central Glory façade forward to the altar and surrounding apse. Starting from the other side of the Carrer Mallorca, the visitor will cross a bridge, still to be built, towards visions of the creation sculpted on the exterior wall. Below, in the tunnel, amongst the petrol fumes of passing traffic, lies hell. Crossing the *Via Humanitatis* at the transept is what Puig calls the *Via Christi*, which starts quite logically outside the Nativity façade, depicting the birth of Christ, and leads across in front of the altar, a great stone sarcophagus, onward to Subirachs's Passion façade. The final route, the *Via Ecclesiae*, is in essence a conflation of the two previous routes but focusing on ritual spaces like the Baptistry. It is circular – an alpha and omega journey. At each point Puig illuminates details with biblical fragments of text or key phrases from the Nicene Creed, drawing us back to the orthodoxy that sits at the heart of this most unorthodox space.

Everywhere there are fascinating details. If there is one text key to explaining the Sagrada Família, it is the prophetic and disturbingly enigmatic visions of Saint John on Patmos. High above the altar a single circle of light, surrounded by twenty-four openings, alludes to the musicians in the Apocalypse who surround Christ in Majesty seated in his *mandorla* as depicted in so many Romanesque altars, Puig suggests. On the exterior walls, serpents, lizards and other reptiles face downwards as if scurrying under a rock, off en route to the underworld, symbolising, according to Puig, Christ's victory over evil.

By 2005 the interior of the Sagrada Família, with its stained-glass windows fitted high in the Nativity façade, began to assume an air of finality. The following year work started on the choir stalls that flank the nave. By 2009 the vaulting over the nave and apse was completed. At last the junta would no longer have to worry about the weather for the masses and celebrations set against the backdrop of the Passion façade. The public's attention now moved indoors to study the staggering new space. Despite the grandeur of Subirachs' four great bronze doors, covered in a minutiae of script and cryptic clues, his Passion façade still drew its fair share of criticism. Having been so polemical in the past, it certainly benefited from the change in focus as it was reabsorbed back into the whole.

On Sunday 7 November 2010 Pope Benedict XVI consecrated the Sagrada Família in a service made especially poignant as he anointed a massive block of rose-coloured stone with perfumed chrism oil, a blend of olive oil and balsam. Particularly moving was the papal blessing received by Jordi Bonet, the senior architect in an unbroken line that goes back to Gaudí himself. It was without a doubt the most important day in the Sagrada Família's history since the foundation stone had been laid back in 1882. Pope Benedict's address was appropriately prophetic:

> The joy which I feel at presiding at this ceremony became all the greater when I learned that this shrine, since its beginnings, has had a special relationship with Saint Joseph. I have been moved above all by Gaudí's confidence when, in the face of many difficulties, filled

with trust in divine Providence, he would exclaim, 'Saint Joseph will finish this church.' So it is significant that it is also being dedicated by a pope whose baptismal name is Joseph.

The meat of Pope Benedict's homily was as traditional as expected. Like Gaudí, however, he also stressed the evangelical power of beauty, arguing forcefully that it was 'one of mankind's greatest needs'.

In Barcelona there were a few dissenting voices who protested against the pope's views on abortion and homosexuality, but they could not spoil the party. Pope Benedict was there to give voice and authority to Gaudí's firmly held belief that he was not creating Europe's last Gothic cathedral but rather the first of the new Christian era. This apparent contradiction gave a fascinating insight into the tension that sat at the heart of Gaudí's work. Both Gaudí and Pope Benedict's modernity seem sometimes as old as the hills. The Sagrada Família, with its roots firmly in the past while building for the future, is a strange anachronism. When finally finished, how will it sit in the expanding cityscape?

Cities are always in flux, both threatened and enlivened by the condition of change as an enduring reality. During planning for the papal visit the Sagrada Família had been served notice that the city's need for an AVE high-speed rail link, burrowing deep underground dangerously close to the basilica's foundations, took precedence over supposed safety issues.

Back in 2007 the group SOS Sagrada Família had released an alarming film in which they simulated the

collapse of the temple. In 2009 ADIF, the company in charge of the high-speed train link running north to join the French network, commissioned an independent report from Intemac, which reported that more vibrations were coming from the Sagrada Família's own building site than the tunnelling could possibly produce. Using all the legal options open to them, the Junta Constructora had their petition to stop the works rejected three times by the Audiencia Nacional, which on no less than six occasions requested detailed reports on the potential seismic vibrations produced by the tunnelling. Just months after the pope's visit, in November 2010 the Spanish Congress debated again the dangers to the safety of the Sagrada Família, which back in July 2005 had been declared a World Heritage Site of 'outstanding universal value'. The right-wing PP party, in opposition, declared their support for the junta. With elections looming, the issue had become highly politicised. The PSOE Socialist Minister of Public Works and Transport, José Blanco, argued it was all about finance. To reroute the AVE would increase costs and delay by up to four years the necessary rail link with France.

ADIF, throughout the works, had kept the public informed of their exacting safety measures, which included more than 8,000 vibration sensors and the placing of more than a hundred reinforced concrete pillars, with another 146 sensors placed on the Sagrada Família site. By July 2011, just months before the elections, tunnelling had passed through the danger zone. The junta's obstruction to the AVE, however, had the potential to backfire, with

voices claiming that perhaps the development of the Sagrada Família might do well to stop where it was.

The ambitions for the Sagrada Família are, as we have seen, enormous. They always have been. Spiritually it was hoped that as an expiatory temple it could offer moral, social and religious direction and pardon society's multitudinous sins. As a building it was going to represent the New Jerusalem. It would become the Cathedral of Europe just as the whole utopian edifice of Europe was coming unstuck.

In 2012 back at the Sagrada Família there was another changing of the guard as the remarkable 87-year-old Jordi Bonet finally retired in favour of Jordi Faulí i Oller, who like so many architects before had started working on the Sagrada Família before qualifying, back in 1990. Faulí's speciality, like his colleague Mark Burry, was the use of CAD programming to analyse the build.

Despite the recent setback in failing to stop the AVE line, work went on. Etsuro Sotoo, the Japanese sculptor, continued to add detail. The fifteen angels that had been placed on the Nativity façade were still recognisably within the Gaudí style pioneered by the Matamalas at the beginning of the twentieth century. It was when Sotoo learnt not to try to imitate Gaudí but instead sculpt in the spirit of Gaudí that we saw his real character. The fruit on the pinnacles planned by Gaudí were now more idiosyncratic and recognisably the work of Sotoo.

In the summer of 2014 Sotoo put in place the first of four giant bronze doors, each one measuring 7 metres by 3, at the entrance to Gaudí's Nativity façade. For Sotoo, whose passion for the Sagrada Família sprang out of his

love for stone, this represented a new departure. It is with these doors that Sotoo comes into his own. Predominantly green, the doors are covered in bronze ivy, pumpkin and lily flowers and a host of insects. They are joyous; as exotic as Klimt or a Japanese print; as exuberant as a pool of Monet's water lilies. They are delightfully whimsical, playing to the inquisitive child who spies a bug or butterfly. Sotoo has hit the right register, where popularity and accessibility meet at the door of craft.

The future of the Sagrada Família is no longer in question. It is not a matter of if but when. The final decoration, if judged by progress on the Nativity façade, which took more than a century to complete, is still an age away. In Catalonia the Catholic Church has often been brave and highly innovative in commissioning art. The twelfth-century Christ in Majesty from Sant Climent de Taüll still stands as one of the greatest images in the history of art. Closer to us is the decision of the junta to offer the Sagrada Família to a novice architect who had never worked on that scale. Closer still is the decision by the chapter of the cathedral in Palma de Mallorca to offer the Santísimo Chapel, to the right of the high altar, dedicated to Saint Peter, to the avant-garde artist Miquel Barceló, who created a riotously decorative ceramic wall depicting the miracle of the loaves and fishes. Right at the other end of the spectrum, in 2015 the director of the museum at the shrine of Montserrat persuaded the internationally famous abstract artist Sean Scully to decorate the chapel at the Benedictine monastery of Santa Cecilia de Montserrat.

Scully's triumphant austerity brings us back to where we began. In *L'Art Sacré* Father Couturier had stressed the

intimate relationship between art and faith: 'It was an unbroken tradition: century after century it was to the foremost masters of Western art, diverse and revolutionary as they might be, that popes and bishops and abbots entrusted the greatest monuments of Christendom, at times in defiance of all opposition.'

What I hope I have offered you with this *Sagrada Família* is not just a building but a community of ideas whose rich past has shaped an exciting future. High on the walls Gaudí inscribed the alpha and omega logos. In the beginning is its end and in its end a new beginning.

# EPILOGUE

Serendipity has always had a large part to play in my relationship with Gaudí. I can still remember my shock and disbelief on discovering that the Mas de la Calderera in Riudoms was just a few hundred metres up the flash-flood riverbed from where I had played as a child, under the railway bridge, catching bats, running from scorpions and smoking my first, and only, Celta cigarette.

In nearby Montroig del Camp we had become close friends with the Bargalló family, who farmed the lands next to Joan Miró's farm. It meant nothing to us then. Years later, however, Rosita Bargalló, my sister Marianne's close friend, disappeared to enter a convent of the Teresian sisters in Tortosa. We lost contact when she went to Rome. Forty years later I managed to talk my way, on a Sunday, into the Teresian convent in Barcelona, built by Gaudí. The Mother Superior was curious about how a Dutchman had become so fascinated by Gaudí, so I explained to her the kindness and generosity of our Baix Camp friends. 'How strange,' she said, 'one of our dear nuns died last week and Rosita has come for a few hours to attend the funeral.' She was upstairs having breakfast, and as she came down the stairs, that beautiful radiant smile I remembered as a child brought me to tears.

No less surprising was the visitor who turned up at the door of my home in Bridport when I was

busy finishing my biography of Antoni Gaudí. For three-quarters of a century, Gaudí enthusiasts and experts in Catalonia had been trying to discover who the mystery man was who had tried to save his life after finding him run over by a tram. My visitor Joan Bolton lived just a few streets away in the lively market town, and had spent every summer in Catalonia with the family of Ángel Tomás Mohíno, the man who ran to Gaudí's assistance.

I also remember a strange set of coincidences back in 2002, during the wonderful Año Gaudí celebrations, which had boosted Gaudí appreciation for a new generation. I was there in Barcelona preparing myself for my first Diada de St Jordi, the Catalan national book day, when open-air book stalls, and flower stands selling single red roses, transform the city into a wonderful festival of literature. Walking down the Gran de Gràcia to my first signing, outside La Pedrera, I spied through the grilled shop window of the quaint Libreria Viuda Roquer the title of a new book on Gaudí that had obviously passed me by. I started to leaf through the book, *Comillas: Preludio de la Modernidad*, by Maria del Mar Arnús with trepidation and found myself absorbed by the clarity of the text to the point where I was almost late for my own appointment. I don't know why, but I felt the need to tell the author how wonderful it was, sought her out in the phone book and that afternoon was invited for tea. Over Gaudí gossip, she asked me what I was working on now. '*Guernica*,' I replied. 'How strange,' she said, 'just this morning I sent my uncle-in-law the architect Sert's correspondence with Picasso to the Musée [Picasso] in Paris.'

I couldn't believe it. Neither could I, on returning to Gràcia to have drinks for the first time with the great Gaudí expert Daniel Giralt-Miracle, believe that he had actually been there in the Casón del Buen Retiro when Picasso's great masterpiece first arrived in Spain. Two chance encounters all in one day.

And so it goes on. On 28 July 2014 I was driving back to Barcelona after a weekend in my beloved village of Arevalillo de Cega up on the edge of the Castilian *meseta*, where we had just celebrated the tenth anniversary of the Asociación Cultural Arevalillo Vivo. On entering the city the heavens opened dramatically in the nearest thing to a full-blown monsoon. Running for cover to the Restaurante El Roble on the Riera de Sant Miquel, I took a place at the bar next to the only other client, an elegant gentleman sipping quietly at his tea.

From the side I recognised my companion. By chance I had found myself sitting next to the man known in his home country as the Japanese Gaudí, the sculptor Etsuro Sotoo. This was most certainly not his normal port of call – in fact, it was Etsuro's first time in El Roble; he, like me, was escaping from the storm.

I remembered reading a news report in March 2014 that Esturo Sotoo, who was highly active in promoting Gaudí's beatification, had travelled to Rome in the company of José Manuel Almuzara, the acting president of the Association for the Beatification of Antonio Gaudí, to offer to Pope Francis a copy he had crafted of Gaudí's bust his taken directly from his death mask. Of course, a wax cast taken from Gaudí almost immediately

after his death has the stamp of verisimilitude, but it is far from a hollow shell, and still at one remove breathes his passion and determination in the face of death with a mysterious strength.

Sotoo's background is completely atypical. Aged twenty-five, back in 1978 Sotoo left his home city of Fukuoka on the shores of Japan's Kyushu island and the relative safety net of his job as professor of art at Kyoto University. His pilgrimage to Europe, like that of so many other Japanese, was an essential part of getting acquainted with European culture and its plethora of museums and cathedrals. Having started his odyssey in Paris, the art he saw didn't speak to him. He felt it dead. Planning to move on to Germany, he had a week to fill and took the train to Barcelona. It was there that he came upon the Sagrada Família in its strange solitary state of abandon, and was instantly seduced by the blocks of stone waiting to be carved.

Sotoo was searching for something less superficial than McCann-Erickson's Japanese advert for Suntory whisky from the 1980s, which used the backdrop of some of Gaudí's signature creations. Through misty shots peopled by strange sci-fi creatures, the viewer learnt that Gaudí's buildings came from either a distant past or a distant future. 'This is a house built by life itself.' It brought the tourists in droves. (This bizarre piece of marketing can be found at the following link: http://bit.ly/1KlgFbz.) But Sotoo's fascination was far more than skin deep.

Persuading the architects Puig Boada and Jordi Bonet that he was willing to work, Sotoo fought off the local competition and ended up as the principal sculptor on

site. Struggling to decipher Gaudí's code, Sotoo eventually had the revelation that he should try to imitate Gaudí's vision of nature and the spirituality that emanated from that humbling encounter between man and the grandeur of God's creation. After a decade doing battle with hammer and chisel to uncover Gaudí's vision, Sotoo decided to take the next step. In 1991 he was baptised in the crypt of the Sagrada Família, where he adopted the Christian name Lluc Miquel Àngel in honour of Saint Luke, the patron saint of artists, and the great Michelangelo.

Before my encounter with him, I had followed Sotoo via his numerous interviews and lectures. His voice was quiet but direct: 'I invite everyone who wants to know Gaudí not to pick the wrong door. If you really want to know him, find the door of spirit and faith.'

This was followed by another question: 'Why do we build the temple of the Sagrada Família?' Which naturally led him on to the simple and more fundamental question: 'Why do we build?' Sotoo's answer was typically Gaudínian: 'We don't seek beauty in the vanity of men. No! The Sagrada Família is a tool for building us. Gaudí left the temple half finished. The temple of the Sagrada Família perfectly built the man Gaudí.'

And Sotoo is right. It is impossible to think of Gaudí without referencing his final masterpiece. It is just as impossible to come to an understanding of his character without taking into account what the building meant to him and how it transformed him as he created a new language of architecture and faith.

In another interview Sotoo discoursed on Gaudí and the centrality of love:

> To stop at Gaudí's architecture and not see the meaning of his work would mean not to know him. The Holy Family itself is like a great encyclopaedia in which there are topics that have answers, but Gaudí is much more than this.
>
> It would worry me if the Holy Family acquired a purely economic dimension or impetus for fame: what is important is to seek truth and not to be afraid. There is no art, culture, or even material without love.

In El Roble, with the storm and rain lashing at the window, Sotoo stressed the importance of faith. I told him that I was writing about the Sagrada Família and he knew my work on Gaudí. 'Promise me one thing,' he begged. 'Look at Gaudí through the eyes of faith. Without this you will be blind.'

I took on board Sotoo's warning and am sure that there is space for the inevitable disagreements and misunderstandings. As a lapsed Scots Presbyterian, I hope that he will see that I have tried, in an ecumenical spirit, to walk the extra mile. Considering the past prejudice directed at Gaudí by serious architectural historians and the Protestant faith, I hope I have remained suitably judicious. If the ambition of the new Sagrada Família basilica is to function as an area for serious debate, it will listen to harsher criticisms than those aired in this book.

The building continues. The ambition for a completion date of 2026 now no longer seems impossible. The body of the church is not just an edifice in stone; it is its congregation. Perhaps, more importantly, the Sagrada Família will have to face its most pressing problems when the builders have finally left the site. How does a church connect with its people when they have to pay to get in?

Today it has become commonplace to hear bishops from all around the world and from all religious denominations ringing the alarm bells with regard to their shrinking flocks and the staggering cost of upkeep of crumbling façades. The Sagrada Família's problem is not its lack of visitors but rather the opposite. How does it control the flow of pilgrims and function as a sanctuary for prayer? And how will its reaching out for universal appeal marry with its parishioners' immediate local needs? Most important for Barcelona is how the Sagrada Família can find a way of re-engaging the sympathies and understanding of the congregation that over its troubled history it has lost. When, on Saint Joseph's Day in 1882, the first stone of the expiatory temple was laid, it was impossible to imagine how complex and often conflictive its future would be.

It is only fitting that the Sagrada Família's architect should have the last word. Gaudí, as he so often said, made the observation that God, his client, was in no hurry to see it finished.

# ACKNOWLEDGEMENTS

First and foremost, I would like to thank all our neighbours in the Castilian village of Arevalillo de Cega, in the province of Segovia, who with extraordinary generosity have opened up your hearts and continue to welcome us into your lives.

At the heart of the village stands our beautiful church, whose graceful silhouette rises high above the garden wall. My late beloved father-in-law John Coulter loved this view and the phantom sounds of the sheep bells as they ring out and echo across the neighbouring hills. He is deeply missed by us all. You were the rock on which we built our house, dear, dear, kind man; thank you from the bottom of my heart. You were a very gentle giant. We will fill the vacuum you have left with many happy memories. For thirty years now we have lived in Arevalillo de Cega. We have shared everything from moments of personal grief to amazing fiestas and, of course, thousands of hours of wonderful conversation. We have been blessed by your friendship and, above all, value the moments when we sit down and break bread together.

Over the years I have come to appreciate the centrality of the church in our everyday life. I have been particularly fortunate that our two priests, Don Rafael and Father Santos, have been prepared to share their mutual love of the glorious Romanesque style. Without our

friends in Arevalillo de Cega, and the profound lessons you have taught us in *convivencia*, this book would have been very different.

Loly and Peter Poguntke from Valdevacas: a big, big thank you for everything but most of all for your friendship. In Turégano we have shared with Eduardo, Rosa, Felisa and Ricardo their pride in their church. Through the villages of Segovia our net spreads out towards the city itself: Teresa, Ángel, Cruz, Nieves, Carlos Angulo, Joy, Tom, Rebecca, Juan José, Pilar, Juan Manuel, Vicky, Gloria, Ana, Diego, Luis, Fernando, Matilde, José, Leo, Julio, Paloma, Andrés, Charo, Tony and Gema Sanz, Lara, Carmen, Rafa, Mazaka, Miguel Ángel. . . all of you are very dear to our heart and give us life.

In Madrid I have been lucky enough to feed off and share the profound knowledge of Paloma Soria, Arturo Colorado, Veva Tusell, Miguel Cabañas Bravo, Ignacio Zuloaga, Margarita Ruyra de Andrade, Sofia Barroso and Julieta Rafecas. I thank you. In Ubeda, Andrea Pezzini, Francisco Vaño and Pepa Higueras: your stars shine bright. In Granada, Glenda Fermin and Alfonso: you also passed on your wisdom. In the Basque country I adore Garbiñe Goia and the great Julián Serrano. In Valencia, Marta, Sergio and their little tribe have been true, loving and loyal.

To all of those who have survived a crisis in the pursuit of excellence I take off my hat: Martin Randall and the team, Manolo de la Osa, Martín Berasategui, Sergi Arola, Nicolas Subtil, José María and son Pedro, Nandu Jubany, Manuel Berganza, Metodiyka, Julio Fernández, María de las Marías, the two Carlos Leóns, Sonia Boue, Jennifer Roger, Jai, Jeremy Shaw, Yana Boheyna, Simon McGookin,

Elena Arzak, James McDonaugh and many, many more. To those who have suffered, may you take solace from the extraordinary wisdom and compassion of Pope Francis, who has given us all a masterclass in humility and faith. May God bless you.

Mentors and friends Paul Preston, Xavier Bray, John McNeal, Helen Graham, Carmen Giménez, the late Michael Jacobs: you have been as generous and stimulating as always.

The theatre of this book, of course, has been Barcelona. Thank you, Nick and Deborah Corper for your kindness and hospitality. Daniel Giralt-Miracle, Juan José Lahuerta, Manuel Castiñeiras, Jordi Gracia García, María del Mar Arnus: you are my reference points and intellectual anchors.

In Catalonia, I thank Jaume Grau, the Bargalló family from Montroig del Camp, Marc and Chris at Bodega Bonavista, all at the Casa Calvet, Armando and Nuria at Capet, Carlos and Maite at La Anxoveta, Artur Sagues, Xavier Sagrista and Toni Gerez. Your amazing spirit and pursuit of reaching for the stars is infectious.

In the Gaudí world, I salute Jordi Bonet, Etsuro Sotoo and particularly thank Laia Vinaixa at the archive.

The genesis of this book has everything to do with the constant support and inspiration of Deborah Blackman. A very big thank you for everything. Euan Thorneycroft, my literary agent at A. M. Heath, has been a rock and Jennifer Custer's enthusiasm is inspiring. I also thank Miguel Aguilar, Jane Bradish-Ellames and Bill Swainson. I particularly want to thank Virginia Fernández at Penguin Random House for her fantastic work, the translators

Jofre Homedes and Jordi Ainaud, also Laura Ortega and Anna Adell, and last but not least, the designer Yolanda Artola.

For this edition in English I particularly want to thank the wonderful editorial and design team at Bloomsbury with a special thanks for the unflagging support of its brilliant editor-in-chief, dear Alexandra Pringle, who was there right at the beginning of our Spanish adventure almost thirty years ago.

It is my family, of course, who has lived this book with me. So Hendrikus, may your charity, Action for Conservation (www.actionforconservation.org), your wisdom and your open heart flourish. Rosa and Hetty, may your spirits continue to soar. My dearest Alex, just a very big thank you for everything we share. My mother-in-law, Estelle Coulter – *mi casa es tu casa*. To ring the changes: a toast to Ryan Pepin. And my new daughter Sophie: welcome home. Finally, Frances and François de Menthon, may the love of our children bring us together as we celebrate their lives.

# INDEX

# A NOTE ON THE AUTHOR

GIJS VAN HENSBERGEN is a Dutch art historian, food critic and Hispanist. A former Harry Ransom Research Fellow at the University of Texas at Austin, van Hensbergen is now a Fellow at the LSE. He has given lectures across the world, including at the Museo del Prado, the University of Oxford, the Queen Sofia Spanish Institute and the Smithsonian in New York, the National Gallery in London and at the prestigious El Escorial summer school, Universidad Complutense, Madrid.

He appears frequently on BBC Four and Radio 4, TV3 and TV España and has contributed to, among many others, the *Guardian*, *The Times*, *El País*, *La Vanguardia* and the *Economist*. Gijs van Hensbergen leads specialist guided tours to Spain and the United States.

gijsvanhensbergen.com

# A NOTE ON THE TYPE

The text of this book is set in Perpetua. This typeface is an adaptation of a style of letter that had been popularised for monumental work in stone by Eric Gill. Large-scale drawings by Gill were given to Charles Malin, a Parisian punch-cutter, and his hand-cut punches were the basis for the font issued by Monotype. First used in a private translation called 'The Passion of Perpetua and Felicity', the italic was originally called Felicity.